OIL PAINTING

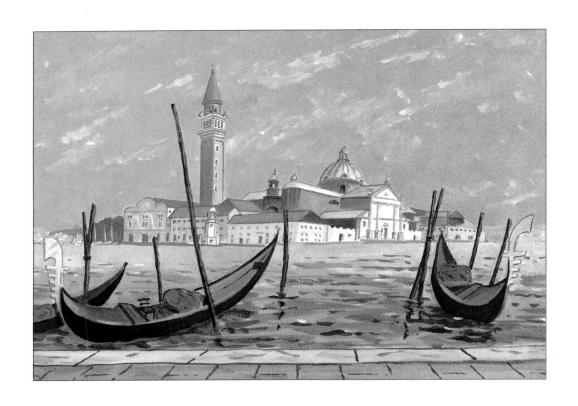

邪 RAVETTE PUBLISHING

Copyright © Philip Berrill 1996
Written and Illustrated by Philip Berrill
First published by Ravette Publishing Limited 1996
All rights reserved. No part of this publication may be reproduced, stored in a retrieval system, or transmitted, in any form or by any means, electronic or mechanical, by photocopying, recording or otherwise, without prior permission in writing from the publisher.

Printed and bound for Ravette Publishing Limited,
Unit 3, Tristar Centre, Star Road,
Partridge Green, West Sussex RH13 8RA
by STIGE, Italy.
Photography by Peter Raymond, Southport.
Origination by DL Repro Ltd., London EC1M 4DD.
Typeset by John O'Hanlon, Southport.
ISBN 1 85304 832 1

Winsor and Newton brushes, paints and artists' materials are used throughout this book and are recommended by artist Philip Berrill.

CONTENTS

Philip Berrill "The Flying Artist"	4
Introduction	6
Materials for Oil Painting	8
Let's Mix Colours	14
Methods for Sketching Out Your Subjects	16
Monochrome: Coffee Jug	18
Let's Paint a Landscape	20
Skies	22
Lakeland Landscape	24
Snow Scene	26
Still Life: A Child's Toys	28
Floral Study	30
The Archer	32
"June"	34
Knickerbocker Glory	36
Venice	37
Painting from Photographs	42
Painting Out-of-Doors	44
Portrait	46
Composition	48
Perspective	50
Clown	52
Abstract and Fun Pictures	53
Palette Knife Painting: Making Your Mark	54
A Sunset Painted with a Palette Knife	56
Griffin Alkyd Paints	58
Glazing and Scumbling	59
Oil Bar	60
Varnishing and Framing Oil Paintings	62
Exhibiting and Selling Your Work	63
Details of Philip Berrill's Newsletter	64

EVERYONE'S GUIDE TO OIL PAINTING CONTAINS 21 DEMONSTRATIONS FOR YOU TO TRY.

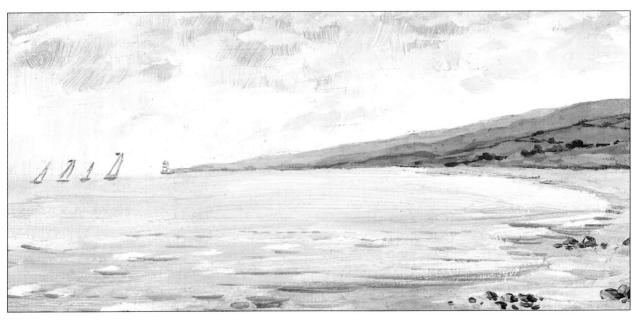

Philip Berrill "The Flying Artist"

Philip Berrill was born in 1945 in Northampton. Philip is a professional artist, art tutor, lecturer and author whose techniques and methods of learning to paint are taught and enjoyed worldwide. Philip now lives in Southport with his wife Sylvia. They have a daughter Penelope. Philip first recalls discovering paint from the age of three. It was one sunny summer afternoon. Philip wandered into his father's glasshouse. At the end of the glasshouse stood a large bucket of whitewash and a tubular pump-type sprayer. Philip loaded it with whitewash from the bucket and had a lovely afternoon spraying all his father's best tomatoes and plants white. The entire inside of the glasshouse was covered with whitewash. Philip had discovered paint, and that with paint you could change the world. His father returned to find his glasshouse a white house and his son dripping from head to foot with whitewash, a white paint.

At the age of 14 Philip decided he wanted to make a living as a professional artist having always enjoyed art at school where he came under the influence, and studied under, the Welsh artist and tutor, John Sullivan. Philip's love and enthusiasm for sketching and painting is infectious. He believes that art should be for everyone and enjoys passing on his enthusiasm and knowledge of how to sketch and paint, gained over 30 years, to people of all ages. His art courses, TV art series and "Painting for Pleasure" Roadshows have always proved popular and in great demand worldwide.

Philip held his first one-man exhibition at the age of 18. Other group and one-man exhibitions followed.

Philip Berrill at work painting a mural for an indoor swimming pool.

When he was 28 a major exhibition of his work was held at Liverpool University. It was opened by the renowned BBC radio and TV broadcaster Brian Redhead. As a direct result of this exhibition Philip realised his ambition to become established as a professional artist and launched his very successful art classes using his own special approach to teaching sketching and painting. These proved so popular the artist developed his worldwide correspondence art courses. In the 1980s painting holiday courses in Great Britain followed and these led to organising and tutoring on painting holiday courses in Europe, in Rome, Venice, Florence and Paris. Philip was invited to lecture and demonstrate painting on sea cruises. Demonstration and lecture visits followed to Houston, Dallas and Dubai. Philip's exhibition, 'The Italian Connection', an exhibition of his sketches and paintings of his Italian journeys and other European locations was very well received.

Philip enjoys painting everything from miniatures to murals. His paintings and signed limited edition prints are owned by patrons and galleries worldwide. His murals are found in private and public locations.

Philip, whose sketching and painting courses and techniques are designed to be suitable for people of all abilities and all ages, found great enjoyment in the challenge of producing his own art videos. These led to the invitation to produce and present his own 13-part television series, "Paint with The Flying Artist", and now to the invitation to write and illustrate his own series of art books specially for you. The books "Everyone's Guide to..." are designed to cover a wide range of mediums, techniques and subjects to introduce you to the joy and pleasure of sketching and painting.

Right. Many people are fascinated by portrait painting. Here artist Philip Berrill is seen passing on useful hints on technique to students.

Below. Basilica of the Madonna della Salute, Venice.

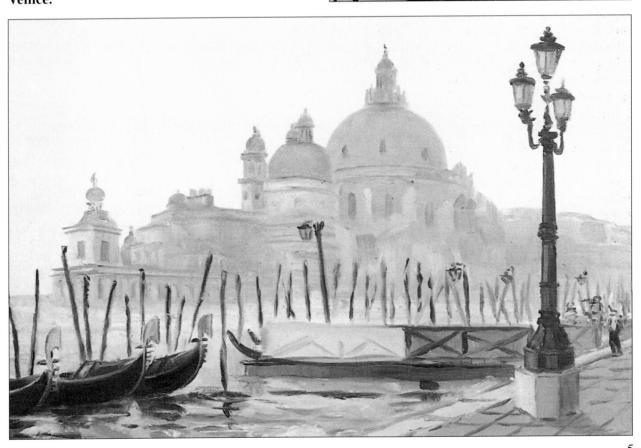

Introduction

I fell in love with oil paints at the age of 13. I was always interested in art as a schoolboy. One day I went into my art teacher's storeroom and was met for the first time by the rich, wonderful, aromatic smell of oil paints. The storeroom was in darkness. I switched on the light. There before me, in neat boxes, were row upon row of brand new, untouched oil paints, rows of oil painting brushes, new, unused canvases and painting boards, bottles of a liquid named linseed oil, and turpentine to mix with the paint. When I opened the boxes, the orderly tubes of oil paint looked enticing and seemed to be waiting to be squeezed onto an artist's palette. The range of colours was dazzling, my artistic senses had been captivated by oil paint. It was love at first sight.

I begged my art tutor, John Sullivan, to tell me all about how to use oil paints and to let me try them. He did, and I discovered the joy and picture making possibilities of these paints. To this day my fingers still tingle with excitement as I set out my oil paints ready to put brush and paint to canvas.

Oil paint is user-friendly. It is a medium in which one can achieve great richness and depth of colour and tone. Oil paint can be used opaquely with stiff hogs hair, or stiff synthetic hair, brushes, which impart an interesting texture to each brush stroke. Oil paint can be used with smoother sable, or soft synthetic hair, brushes for a brushmark-free, smooth finish. It can also be used with a painting or palette knife. The resulting highly textured paint layer is known as 'Impasto'. A palette knife painting is best viewed from a distance of several feet.

Oil paints offer great freedom to both the newcomer to painting and the more experienced painter. You can paint highly detailed pictures, looser or more impressionistic pictures, or you can create bold, free-flowing pictures with just a few sweeping strokes of a brush. Oil paint pictures can be modified, both during the time the painting is being worked on, or after it is dry. If the paint is still wet, a mistake, or area to be changed, can be carefully scraped off with a palette knife, or wiped away with a clean, dry cloth. If the paint is dry, the area can be overpainted as the paint is opaque.

Oil paintings can be produced by the technique known as "Alla Prima", that is wet paint on wet paint, or can be built up in stages, layer by layer, allowing each layer to dry, or become touch-dry, before the next layer is applied. Thin, transparent washes of oil paints, known as glazes and scumbles, can be superimposed over dry oil paint to achieve other effects.

The aim of "Everyone's guide to Oil Painting" is to give you a sound understanding of the medium and techniques, so that you can use them to create your own paintings, in your own style. If you are a beginner, what joys you have to come. If you already paint, I would like to think I can help you develop your talent and skills still further.

THE ORIGINS OF OIL PAINTING

The Van Eycks have traditionally been credited with the discovery of oil painting. However, it is widely believed by many that oil painting evolved from earlier periods. Early works on the art and technique of painting give recipes for cooked and sun-bleached oils and drying oils. Cennino Cennini's manual on art is an enlightening guide to methods and techniques of the Renaissance period. Northern European artists tended to use oils with pigment before the southern European artists and by the 16th Century most easel painting was produced with oil paint. Before that, paintings had either been frescos, painted onto the wet or dry plaster of walls, or egg tempera paintings done on a

wooden surface or panel. The use of primed canvas stretched on a wooden frame meant that a large painting became transportable. When dry, the canvas could be unpinned from the stretcher and the wooden stretcher frame collapsed. The painting could be dispatched, or taken from the studio, to the customer and re-assembled at its final location.

The convenience of a superb range of artists materials, including paints, brushes and canvases produced by art manufacturers, especially by Winsor and Newton, means that today we can concentrate on the art of painting our pictures, knowing that the experience and needs of artists over the centuries have gone into the formulation of reliable, high quality products that greet our eyes when we visit our local art shop.

Many of my art correspondence course and art holiday course pupils have become highly proficient oil painters, gaining great satisfaction from the medium. Whilst oil paints are suitable for the 12 to 80 plus age range, it is possible for younger people to use them, but I would suggest it be under the supervision of a parent or teacher due to the slower drying time of oil paint compared to water colours or water-based paints.

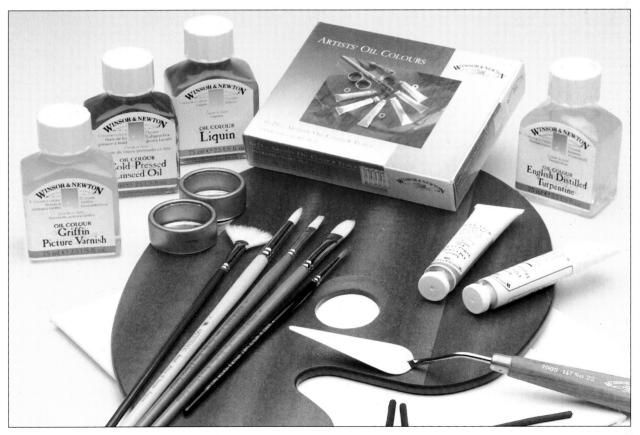

Materials for Oil Painting

OIL PAINT

Oil paints are made by combining pigment with drying, or semi-drying oil. The paint, when exposed to air, oxidises and creates an elastic skin which gradually hardens on the surface of the canvas or painting surface. Cold-pressed linseed oil, poppy oil, safflower oil and soya oil are traditionally the most commonly used oils in the manufacture of oil paints.

Winsor and Newton manufacture an Artists' quality range of oil paints to the highest standards, using the finest ingredients. This is reflected in the price. However, being aware that artists do not have bottomless pockets, they also manufacture the Winton range of oil colours. These are also made to extremely high standards, but within moderate cost limits. The Artists' quality range offers a choice of 97 colours and the Winton range offers 47 carefully selected colours to choose from.

Later in this section I will list what I call the Essential Oil Painting Kit: the materials you need to start with.

MEDIUMS, SOLVENTS, DILUTANTS AND VARNISHES

When looking for the first time at the wide range of bottles of mediums and dilutants available for oil painting in most art shops it can seem bewildering. It need not be. I suggest you start with small 75ml bottles of the following:

COLD PRESSED LINSEED OIL (a medium)

This light yellow oil can be added to the oil paint on your palette. It increases the gloss and transparency of the colour and reduces the effect of the brush marks. Paint mixed with linseed oil can take four to five days to become touch-dry. Linseed oil has a rich odour which always reminds me of the day I discovered oil paints.

DISTILLED TURPENTINE

(a dilutant or thinner)

Turpentine is colourless. Artists use it as a dilutant to thin the oil paint. The resulting dry paint has a matt finish. The paint is normally touch-dry within two to three days. Distilled turpentine has a very pronounced odour. It is flammable and like all bottles should be clearly marked and stored well out of reach of children.

WHITE SPIRIT OR TURPENTINE SUBSTITUTE

This is an economical dilutant for cleaning brushes. It has a characteristic odour which is less pronounced than turpentine. It is flammable and should be stored in the same manner as distilled turpentine.

SANSODOR

This is a low odour dilutant, an alternative to the stronger smelling turpentine.

LIQUIN

Liquin is a popular oil painting medium which can be added to increase the flow, or the transparency, of the oil paint. It allows for smooth brush work, subtle blending, and for the painting of fine detail. It dries quickly; often the paint will be touch-dry within eighteen hours. I find this a great advantage when wanting to build up my picture in touch-dry layers, especially when painting on holiday or on painting expeditions away from the studio.

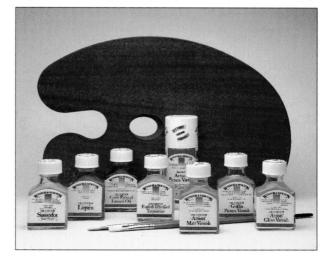

VARNISH

When the picture is dry, a protective coat of varnish is applied. A coat of gloss varnish will impart the traditional glossy look to the painting. A coat of matt varnish, whilst protecting the picture surface from the atmosphere, reduces or eliminates the reflection of light from windows and electric light on the picture's surface. Winsor and Newton's Artists' Gloss Varnish, Griffin Picture Varnish and Matt Varnish are highly recommended. All these varnishes can be obtained in bottles and can be applied to the picture surface with a clean varnishing brush. Winsor and Newton also produce an ozone-friendly can of Artists' Picture Varnish, a gloss varnish, which many painters find convenient. Detailed instructions on varnishing your painting are given in the chapter headed Varnishing and Framing Oil Paintings.

OIL PAINTING SUPPORTS

An oil painting support is simply the surface on which you paint. It can be rigid or flexible. Companies like Winsor and Newton manufacture the supports acrylic-primed, ready to paint on. Acrylic-primed supports can be used for oil painting, acrylic painting and for use with Griffin alkyd paints.

OIL SKETCHING PAPER

This is a stout paper impressed with a canvas-like texture. It comes prepared, that is primed, ready to paint on. It can be obtained in single sheets, but is more commonly found bound in oil sketching pads. It is ideal for trying out ideas when the permanence of work is not essential, but it can tear or crease. If you find you have painted a really good study on oil sketching paper, one you want to keep and frame, the picture, when dry, can be glued to a sheet of acid-free cardboard to provide a more permanent base or support.

OIL PAINTING BOARDS

Robust cardboard with a sheet of prepared oil sketching paper glued to it provides an inexpensive and practical painting surface.

With the availability of good quality, inexpensive, cotton canvas the art materials manufacturers have been able to produce and market an economical range of canvas boards. These come in a variety of sizes and have genuine canvas glued to the surface. They are primed ready for you to paint on.

STRETCHED CANVAS

A stretched canvas is when the canvas has been stretched over a special stretcher frame and has been pinned to the sides of the frame to keep the canvas taut. The canvas usually comes primed ready for painting. It offers the artist a delightful, springy painting surface when compared to the rigidity of painting boards. Over a period of time a stretched canvas can slacken. The tension is regained by gently tapping the wedges in the corners of the back

of the stretcher. The finished painting can be left on the stretcher and framed ready to hang. If transporting the picture ensure it is quite dry. Unpin the canvas from the stretcher, carefully roll it and put it in a strong tube, or pack it flat. It can be delivered to any desired location where it can be re-stretched and framed.

Canvas can be bought, unprimed or primed, by the roll or piece. This is especially useful for large scale work. The choice of texture can also be selected by the artist. Cotton canvas is a pleasant surface for most subjects, but heavier more pronounced weaves can add their own distinctive characteristics to an artist's work.

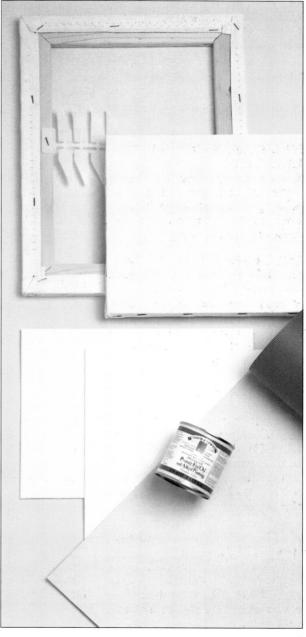

BRUSHES

As the tip of your brush is the most important thing between you and your painting, good paintbrushes are important. A poor brush can hinder a good artist, but a good brush is a joy to use and allows you every opportunity to express your ideas on canvas.

HOG BRISTLE BRUSHES have been used by oil painters for over 150 years. The finest bristle brush keeps its shape, retains its working edge and will hold a considerable amount of oil paint. It will wear well when used on the coarser surfaces some artists like to use. Whilst a little less flexible than the sable brush, it has strong durability if well cared for.

Hog bristle brushes come in five main shapes; Round, Long Flat, Short Flat, Fan and Filbert. The filbert brush starts flat at the base but the hair is domed at the top. Each shape of brush offers the artist its own distinctive brush marks.

SABLE BRUSHES are ideal if you want a very smooth, brush mark-free, finish to your painting, or if painting in detail. The precision given by the point of a round sable brush, or the neatness of the edge of a flat sable brush, is of great importance to the artist. The Winsor and Newton series 7, series 16 and series 33, together with the series 608 flat brushes, are all highly recommended.

SYNTHETIC HAIR BRUSHES are ideally suited to water colour and water-based paints. Whilst synthetic brushes are available for oil painting, very few yet match the performance of the traditional oil painting brushes.

CARE OF BRUSHES. A well-cared for brush is a joy to work with and becomes like a well-trusted friend. After an oil painting session wash your brushes using white spirit or turpentine substitute in a jar. Remove the surplus turpentine from the brushes using a clean, absorbent cloth. With cool tap water running into the palm of your hand and either Winsor and Newton Art Gel, or household soap, work up a lather with the hair of the brushes. When the brushes are clean, rinse them thoroughly with clean water. Shake the brushes dry, reshaping the bristles with your fingers. Stand your brushes bristle-end up in a jar to dry.

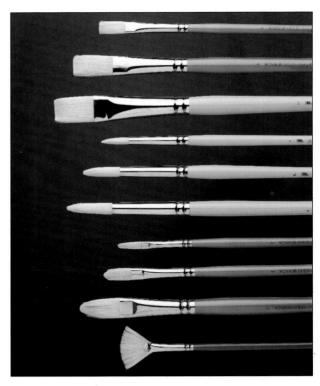

Bristle hair oil painting brushes

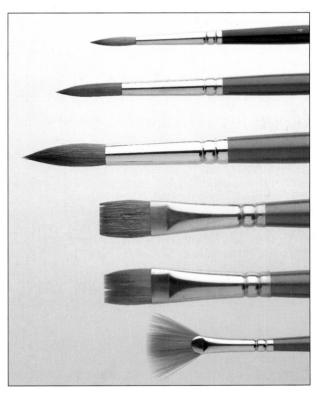

Sable and synthetic hair brushes

PALETTES

Oil paints are mixed on a palette. Wooden palettes come in oval, rectangular or kidney shapes. The traditional palette is usually mahogany veneered. Birch plywood palettes are a lighter, creamy colour. Melamine-faced palettes are white. All need cleaning after use. I recommend the expendable paper palettes. They are clean, economical and the used pages can be disposed of without mess. They consist of 25 to 50 sheets of a special oil-proof paper. They are rectangular in shape, and as with the other palettes, can be held in the hand, or laid beside you on a working table.

DIPPERS. A double metal dipper is designed to clip onto the side of your palette. It consists of two metal containers to hold your painting medium and solvent.

PALETTE KNIVES / PAINTING KNIVES

Palette knives are finger-like, moderately flexible, steel blades in a wooden handle. They are generally used for mixing oil paints together on the palette. A selection of sizes is available. A plastic palette knife is also available.

A painting knife has a cranked handle to help keep the artist's fingers and knuckles away from the painting surface when the painting knife is being used to apply oil paint directly to the picture surface. A medium, diamond-shaped painting knife is ideal to start with.

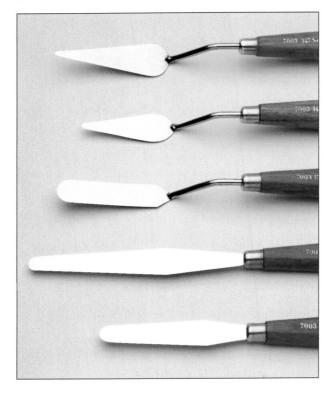

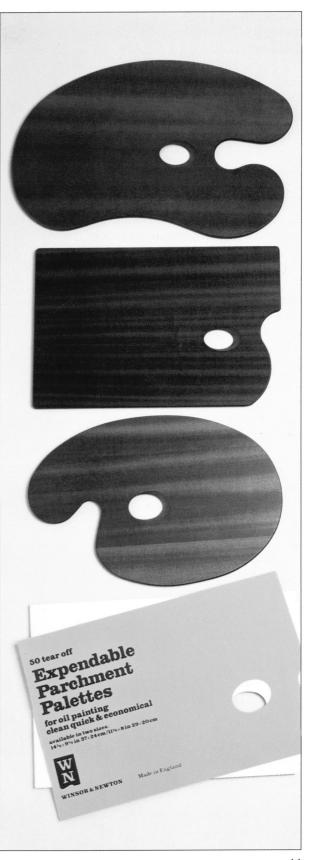

GRIFFIN ALKYD PAINTS and OIL BAR

There have been two major developments in art materials allied to oil paints in recent years:

GRIFFIN ALKYD PAINTS. These are very similar to oil paints but are manufactured from pigments suspended in an alkyd resin and solvent. The main advantage is the speed with which they dry. I find an area painted one day is touch-dry about eighteen hours later. The range of 42 colours, and the even, buttery consistency make them suitable for all the traditional oil painting techniques. Liquin is the medium used to add to the paint instead of linseed oil or turpentine. The brushes are washed out and cleaned exactly as for oil paints.

OIL BAR is a totally new dimension for the artist, offering an exciting new opportunity. Due to their formulation they are different from oil pastels. A mixture of pigment, linseed oil and special waxes, they enable the artist to draw, work and mix directly on the canvas, without using a brush. Oil Bar is available in three sizes.

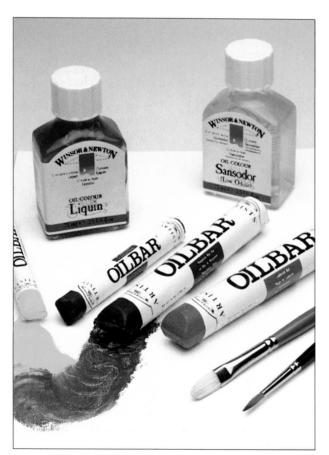

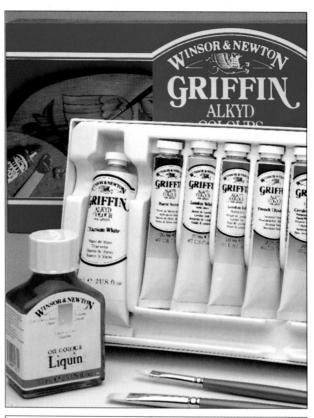

THE ESSENTIAL OIL PAINTING KIT

I recommend the following:

PAINTS

The following nine colours from the Winsor and Newton Artists', or Winton, oil paint ranges. The 37ml size tubes are ideal to start with.

French Ultramarine / Cerulean Blue / Cadmium Yellow Hue / Yellow Ochre / Alizarin Crimson / Cadmium Red Hue / Sap Green / Burnt Umber / Burnt Sienna A larger size, 60ml, Flake White.

BRUSHES

One of each: No. 6 round, No. 10 long flat and No. 8 filbert hog bristle brushes.

One No. 3 round sable brush, series 7, 16 or 33 One No. 1 or No. 2 fan brush

MEDIUM AND DILUTANTS

- a 75ml bottle of cold-pressed linseed oil
- a 75ml bottle of distilled turpentine
- a 75ml, or larger, bottle of artists' white spirit
- a 75ml bottle of Liquin

SUPPORTS

1 each 14" x 10" (356mm x 254mm), 16" x 12" (406mm x 305mm) and 20" x 16" (508mm x 406mm) canvas boards.

PALETTE

An expendable paper, or wooden, palette of your choice. A double dipper to clip onto the side of your palette.

EASEL

A table easel, or sturdy sketching easel, is worth obtaining at the earliest opportunity.

MISCELLANEOUS ITEMS

A piece of medium charcoal, soft absorbent cloth, newspaper and an old overall or smock.

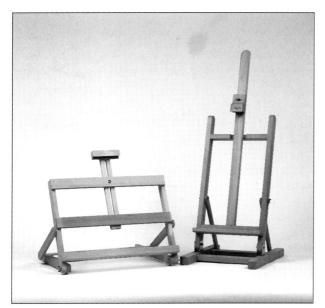

Table easels

EASELS

Oil paintings are best painted on an easel with the painting vertical or at an inclined angle. Winsor and Newton produce an extensive range of table easels to suit all needs. They are especially practical for those artists who like to sit down when painting. They are compact when folded so can be taken to an art class, art club or other painting location.

Winsor and Newton provide a wide range of adjustable vertical easels, from light-weight wooden and metal sketching easels, for indoor and outdoor use, to the more permanent studio easels. In most instances these can be adjusted to standing or sitting positions. A table easel or a light-weight wooden or metal sketching easel make a practical starting point for the newcomer to painting. If space permits, a larger studio easel can be a good investment.

SUNDRY MATERIALS

A medium sized piece of charcoal, some absorbent clean cloth for wiping your brushes, old newspapers to put on your painting table and an overall, smock or old clothes for yourself are all worth collecting. Many people like to keep their art materials neat and tidy in a portable, divided plastic box. It is useful for outdoor painting and for taking your materials to an art class or art club.

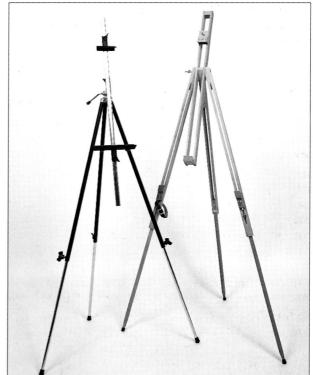

Sketching easels

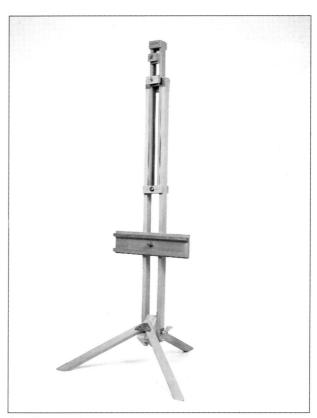

Studio easel

Let's Mix Colours

COLOUR MIXING

The colour charts on these pages are indispensable and are a practical and helpful guide in learning to mix colours.

The first chart shows how the three PRIMARY COLOURS, red, yellow and blue, can be used to make the three SECONDARY COLOURS, orange, mauve and green. The secondary colours can be mixed to make the three TERTIARY COLOURS, dark brown, light brown and olive green.

HOW TO MAKE BLACK

You will also see how the three primary colours mixed together produce black. I also use Burnt Umber and French Ultramarine to make black. I generally advise people not to use black oil paint to darken a colour. It so often seems to dull and deaden the colours and they lose their clarity.

COMPLEMENTARY COLOUR WHEEL

Black is opposite, or complementary, to white. Each colour has its opposite colour. These are shown on the COMPLEMENTARY COLOUR WHEEL: black / white; yellow / mauve; orange / blue; red / green.

It is a good idea to ask yourself what is the predominant colour of your subject and to try to have a splash of the opposite colour in the painting. This can have a dramatic effect.

If you mix any two opposite or complementary colours together in equal amounts, you will make grey.

THE COLOUR TINT CHART

Group your colours in the way I show. Paint a strong tone of the colour in the first of its three boxes, then make a medium tone made by adding a little white paint, then a light tone by adding even more white. This will show you the colour and two of its lighter tints.

The 12 colours on my list will enable you to select from 42 colours and tints when painting your pictures.

GREENS COLOUR CHART

This shows how, with three blues, three yellows, one green and white, you can make a chart offering you 25 greens, ranging from acidy light to rich dark greens, all of value to every one who paints, but especially to the landscape and floral painter.

People I have taught oil painting to have found these charts very helpful and the key to successful colour mixing. I would encourage you to copy out these charts on oil sketching paper. If you paint the charts on paper cut to A4 size, when dry, they can be placed in a clear plastic folder to keep them clean, ready for you to refer to when painting.

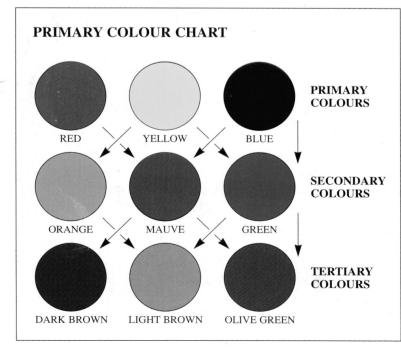

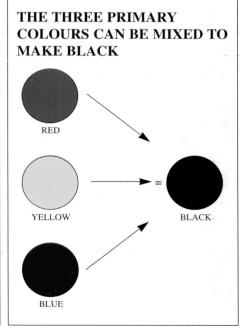

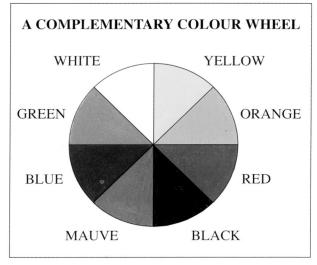

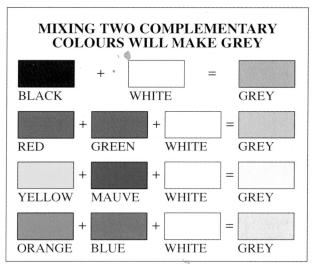

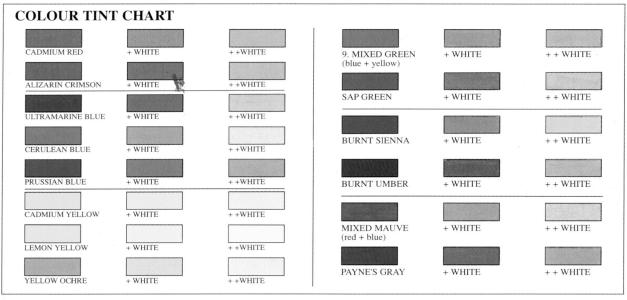

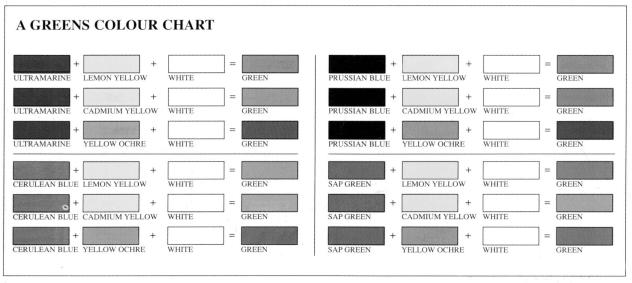

Demonstration 1

Methods for Sketching Out Your Subjects

I am a great believer in making one or two preliminary sketches of the subject I decide to paint. I do these in my cartridge sketchbook, or on some spare pieces of paper, using a 2B pencil. This gives me the chance to examine and explore the subject and to plan my picture. It is a good habit and I recommend it to you as a technique to adopt. However, if drawing the subject on oil sketching paper, canvas boards or canvas, the pencil lines will dissolve and slightly discolour the first paint layer you apply to the picture surface.

The three main methods oil painters use to draw out their subjects on their painting surface are:

METHOD 1. CHARCOAL

Stage 1. Use a stick of charcoal and firmly draw out the subject. The line should look black but will easily smudge.

Stage 2. Use a clean, dry, soft cloth or duster and vigorously dust the surface of the picture. The loose, smudgy charcoal is removed by the duster leaving you with a faint, non-smudgy drawing ready for painting.

METHOD 2.

A FINE PAINTBRUSH OUTLINE DRAWING

Mix a pale grey, or a pale brown, oil paint with turpentine to the consistency of ink. Use a No. 3 or No. 4 round sable or synthetic hair brush. Sketch the picture onto the painting surface. Because of the amount of turpentine used the painted lines will dry out quite quickly. When they are dry you can start your main painting.

HANDY HINT. When you have made your sketch turn it upside down and look at it before you paint it. Any errors will show up and can be corrected.

Method 1. Stage 1 Subject drawn boldly in charcoal

Method 1. Stage 2 Charcoal dusted off

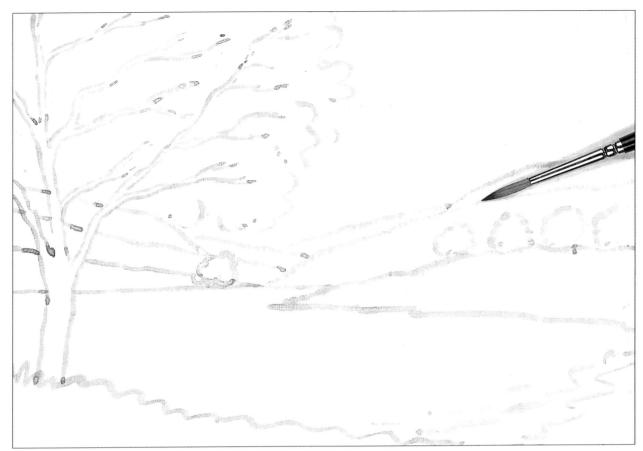

Method 2. A fine paintbrush outline drawing

METHOD 3. SKETCHING AND PAINTING ON A PRE-TINTED PAINTING SURFACE

Stage 1. Some artists find the thought of painting onto a clean, unspoilt surface quite daunting, or prefer something other than pure white to work on. They usually make a thin mixture of turpentine and oil paint, often Burnt Umber. Using a cloth or large brush, they apply the thin colour to the painting surface to tint it. The turpentine in the mixture will evaporate in about 30 minutes leaving a dry surface.

Stage 2. A darker tone of the same colour of oil paint and turpentine can be used to sketch the subject on the tinted background, in the way seen in method 2. Various colours can be used for background tinting. A dull green can make an excellent background for portrait work. This technique is known by the name Imprimitura.

Try each method and you will discover the method best suited to you.

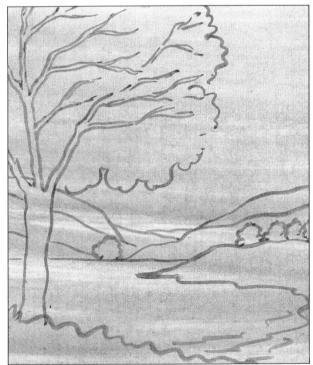

Method 3. Stage 1. Sketching a painting on a pre-tinted painting surface

Demonstration 2 Monochrome: Coffee Jug

I always encourage people to try a monochrome painting. Monochrome means one colour. Use a single plain-coloured item, such as this coffee pot. Painting a monochrome study of it will help you understand how to look for, mix and use the three main tones of light, medium and dark colour. It will help you to discover how to look for the very darkest features and the very lightest features which play an important role in a successful painting.

Stage 1. I suggest that all the demonstration paintings in this book are painted on a support, either oil sketching paper, a canvas board or canvas, measuring 14" x 10" (356mm x 254mm), 16" x 12" (406mm x 305mm) or 20" x 16" (508mm x 406mm). Sketch the coffee pot using the charcoal technique ensuring you dust off the loose charcoal before you start the painting.

Stage 2. Light tone. Mix French Ultramarine and white, using a little turpentine if needed. As the coffee pot is blue, paint the light blue tone, filling in the whole shape of the coffee pot. Use a medium size flat, or filbert, hog bristle paintbrush to apply the paint. Keep the paint quite thick. You don't want to be able to see the painting surface through the paint.

Stage 3. Medium tone. Add a little more blue to the mixture on your palette. Apply the medium tones shown in the illustration. The source of light is coming from the left-hand side of the pot. The shadows, along with the medium and dark tones, will fall to the right-hand side of the coffee pot, away from the light.

Stage 4. Dark tone. Add a little more blue to the mixture on your palette and apply the dark tones. These are seen in the illustration. They are to the right of the body of the pot, under the bulbous lower half of the body, spout and handle, and are also to be found on the base and lid.

Stage 5. Using very dark blue and a No. 3 round synthetic or sable brush, pick out the very darkest features. These are found on the lid, spout opening, handle and base of the coffee pot. Likewise, using a very pale, almost white, mixture of blue and white, pick out the highlights on the jug. Add a background and table top in the way shown. This gives a sketchy look to the background to emphasise the jug. A fully painted background can be painted if you prefer.

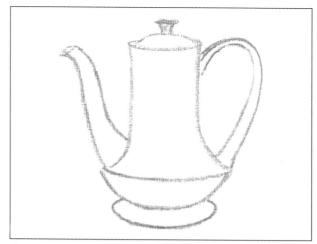

Stage 1

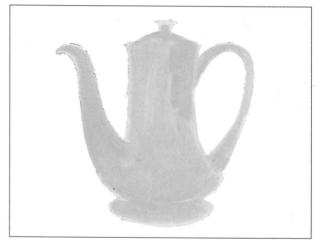

Stage 2

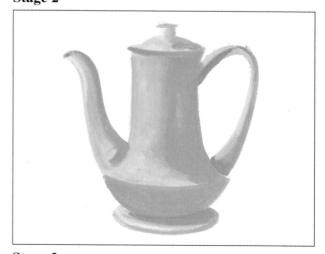

Stage 3

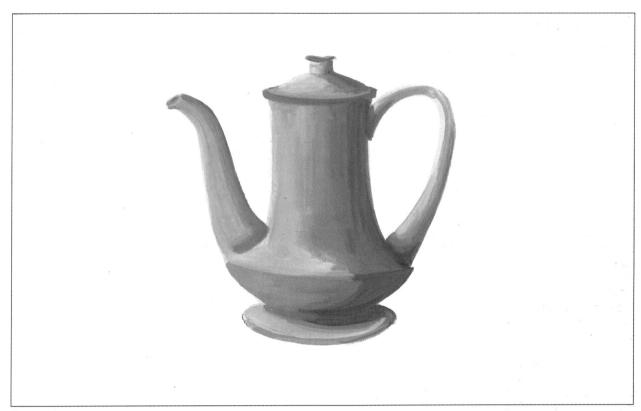

Stage 4

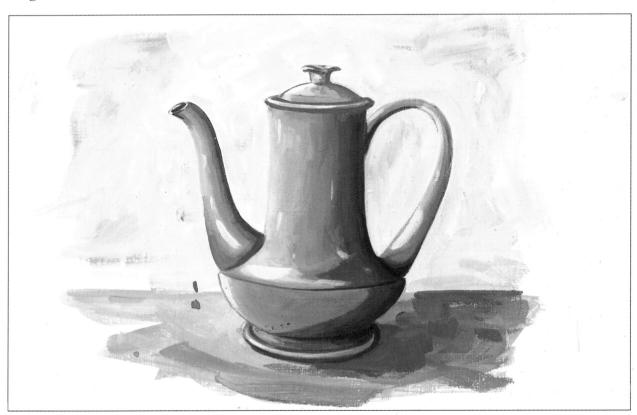

Stage 5

Demonstration 3 Let's Paint a Landscape

Here is an easy, straightforward landscape for you to try using a range of colours. Don't forget to have your own colour charts by your side to check how to make each colour.

Stage 1. Draw the subject using either the charcoal or paintbrush drawing technique.

Stage 2. We will paint each area of this painting using the alla prima technique, where the paint is used thickly and each area is completed while the paint is still wet.

With a large hog bristle brush paint in the blue of the sky using French Ultramarine and white. The clouds can be added with a speck of Yellow Ochre added to the white paint. The pale grey cloud shadows can be painted in using a grey made from a little blue and brown mixed with white on your palette. Some of the many types of brush marks and effects achievable with the round, flat and filbert hog bristle brushes can be seen in the detail panel opposite.

Stage 3. Continue with the above technique for the other areas of the landscape. Mix pale mauve and pale blue for the distant hills. Note how the green hills and fields are paler in the distance, becoming stronger in colour and tone as they come nearer to the foreground. Use greens from your colour chart. I have used greens made from French Ultramarine, Cadmium Yellow and white. I don't like mixing black into a colour to make the darker tones, instead I add a little near black made from a mixture of Burnt Umber and French Ultramarine. This is the method you should use for making the dark greens in this picture. The hedges and trees can now be added.

The road can be added using Burnt Umber and white. The darker tone of the road is made by adding the brown/blue, black substitute, described above. The main coloured areas for the walls and roof of the building can be added with a flat or filbert brush.

Stage 4. The details of the windows, door, chimney stacks, near hedges and fence can be added, as can the detail to the edges of the roadway using your round No. 3 detail brush.

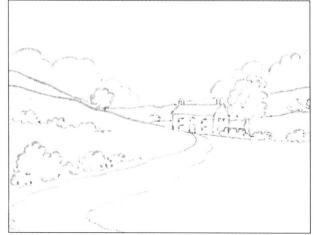

Stage 1

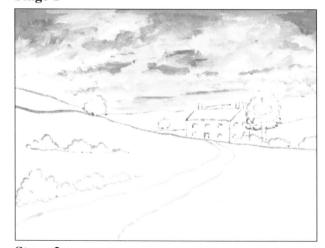

Stage 2

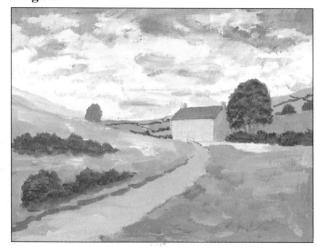

Stage 3

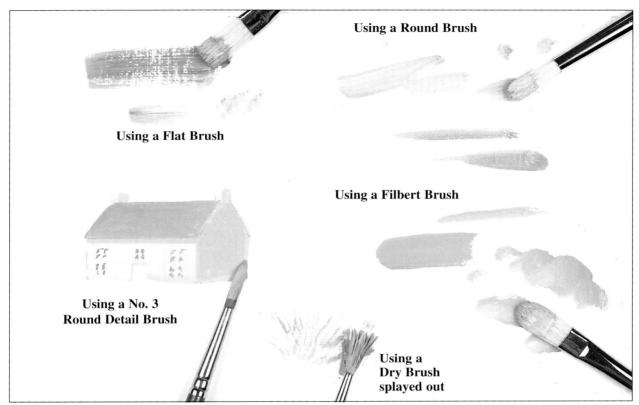

Detail: Brush marks and effects

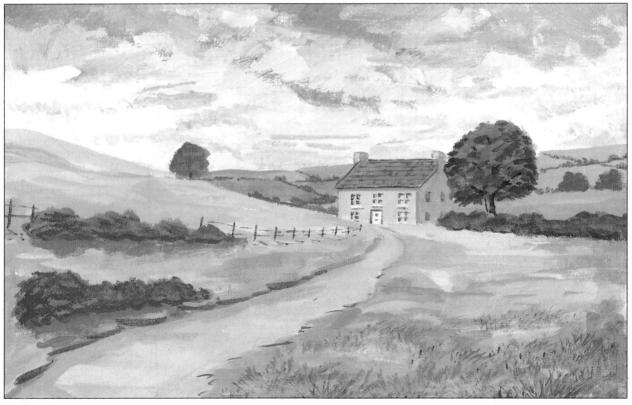

Stage 4

Demonstrations 4, 5 and 6 Skies

The next group of three demonstrations is designed to help you explore painting skies using a range of different colourings and atmospheric effects. Although shown here as square pictures, they can be painted on either a square or rectangular painting board or support.

Demonstration 4 A Blue Summer Sky

Stage 1. Sketch the subject. Mix a little Cerulean Blue with white oil paint. Paint the sky using a stronger blue at the top, gradually lightening it as the sky comes down to the horizon. This is achieved by increasing the amount of white added to the blue mixture.

Stage 2. Use the thin side edge of the filbert brush and white paint to add the fleeting white clouds.

Stage 3. Add the green landscape using the same method used in the previous demonstration.

Demonstration 5 Stormy Sky

Stage 1. Paint a light mixture of Cerulean Blue and white into the top right-hand corner. Mix Prussian Blue and a little white for the storm clouds.

Stage 2. Add a little Burnt Umber to the Prussian Blue and white mixture you have used. Paint in the very dark, deep, base area of the storm clouds.

Stage 3. Paint the back row of industrial buildings in a deep mauve silhouette. Add the foreground building silhouette in a darker mauve by adding a little Burnt Umber and French Ultramarine to the mauve. Finally add the wisp of white smoke from the factory chimney.

Demonstration 6 Sunset

Stage 1. Paint white for the sun. Use Lemon Yellow mixed with white for the area immediately round the sun.

Stage 2. From the edges of the yellow, paint and blend in orange, made by mixing together red and yellow paint. Add Alizarin Crimson to the orange for the deeper red of the sky. Paint the clouds in mauve.

Stage 3. Paint in the silhouetted landscape using a mixture of mauve, French Ultramarine and Burnt Umber.

Summer Sky

Stage 1

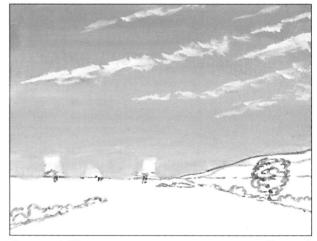

Summer Sky

Stage 2

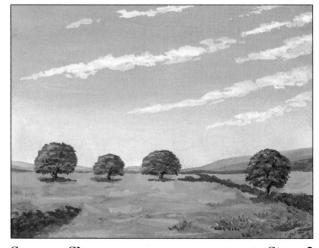

Summer Sky

Stage 3

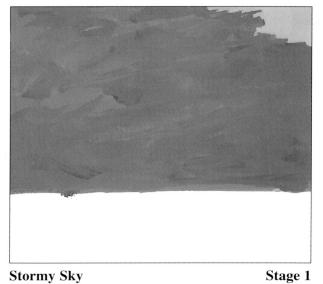

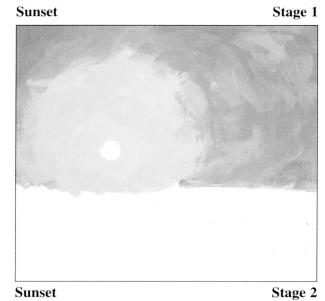

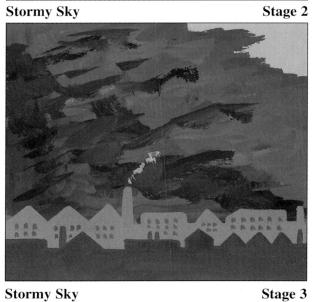

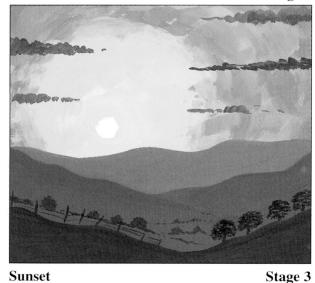

Stage 3

Stage 3

Demonstration 7 Lakeland Landscape

In the first picture demonstrations the Alla Prima, wet on wet, oil painting technique has been used. Each area has been started and finished before moving on to the next area or feature.

In this demonstration you will use a different technique, allowing each stage to become touch-dry. Each stage of the picture should become touch-dry after two to three days. To start, paint a first coat of each main colour throughout the picture. Let the first coat become touch-dry. Then paint over the first coat of colour with a second layer of each colour. With the second layer, the paint takes on a more robust look and the more finished modelling of the picture takes place. Let the second coat become touch-dry and add the details and embellishments.

One advantage of this technique is that if you make a mistake in the second layer, or in adding the final details, the error can be wiped away with a clean cloth dampened with a little turpentine. The area of the painting under the mistake will remain unspoiled and the correction painted on top. Another advantage is that detail can be more easily painted on top of the touch-dry paint.

When using this technique I am often painting two pictures, working on the second picture on the days the first painting is drying.

Stage 1. Draw the subject with the charcoal or paint brush line technique.

Stage 2. Paint the first undercoat of colour for each area, the sky, mountains, fields, lake and main trees. Let it become touchdry.

Stage 3. Paint a second coat of each colour for these areas, but adding the light and shade and thus modelling the picture. The paint layer will look more robust.

Stage 4. Add the detail to the trees, hedges, rocks in the lake and fence with the smaller brushes, including the No. 3 softer, round brush.

Stage 1

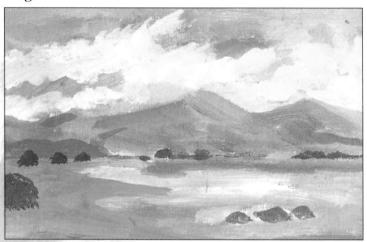

Stage 2

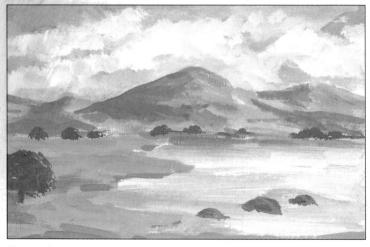

Stage 3

Close up of brush strokes

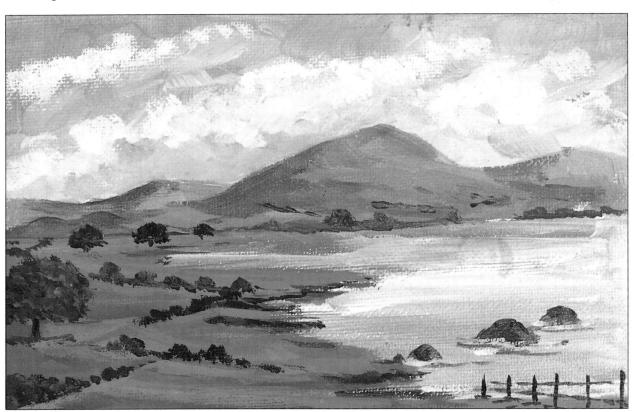

Stage 4

Demonstration 8 Snow Scene

Some of the most spectacular subjects are provided by nature. A snow-covered winter landscape is just such an example and provides the subject for this demonstration.

Stage 1. Sketch out the subject.

Stage 2. Mix together French Ultramarine, Burnt Umber and white. Use a large flat brush to paint the cold, bluish-grey of the sky. This can cover the upper area of the main tree and the edges of the distant trees.

Mix a greyish-brown from the above colours for the background winter trees. The colour of the bridge stonework is made from a little Yellow Ochre with white and the dull greyish-green by mixing blue with some Yellow Ochre and white. Increase the amount of blue and brown in the mixture for the darker coloured underside of the bridge. Burnt Sienna, Yellow Ochre, the dark green mixture and a little white are used to make the various colours for the dead grass and bracken around the sides and front of the riverbank just in front of the bridge. A pale blue mixed with white creates the colour for the river under the bridge and the lighter foreground areas. A darker, almost black-brown made from brown and blue can be used for the darker areas of the river. The main tree trunk is a mixture of Burnt Jr ber with Yellow Ochre and white for the lighter left-hand side, with an increase of blue and brown in the mixture for the darker right-hand side and branches. The larger areas of snow are a mixture of white paint with a touch of Yellow Ochre. The bluish-mauve shadows on the snow are a mixture of white with a little Alizarin Crimson and French Ultramarine. Let this become touch-dry.

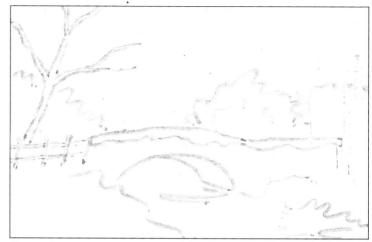

Stage 1

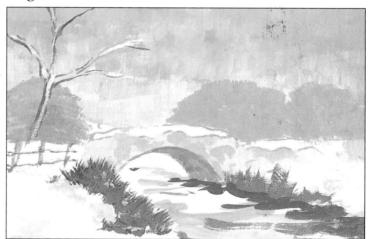

Stage 2

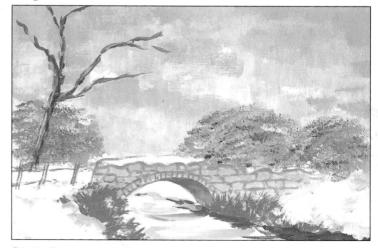

Stage 3

Stage 3. Using a darker tone of the colours used for the bridge in stage 1, add a suggestion of the stonework to the bridge. Use a medium dark grey-brown mixture on the tip of a fan brush, or a dry flat brush, to create a suggestion of more detail to the distant trees. See detail panel.

Stage 4. Mix together Burnt Umber, French Ultramarine and a little white with turpentine to an inky consistency. Paint in the boughs and fine branches of the main tree using a No. 3 round detail brush. Add the rustic fence.

Stage 5. Add the bluish-white snow to the top of the bridge and fence. Pick out the white and darker toned brown grasses peeking through the snow on the banks of the river with a No. 3 detail brush.

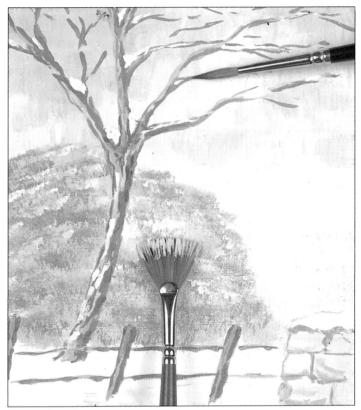

Stage 4

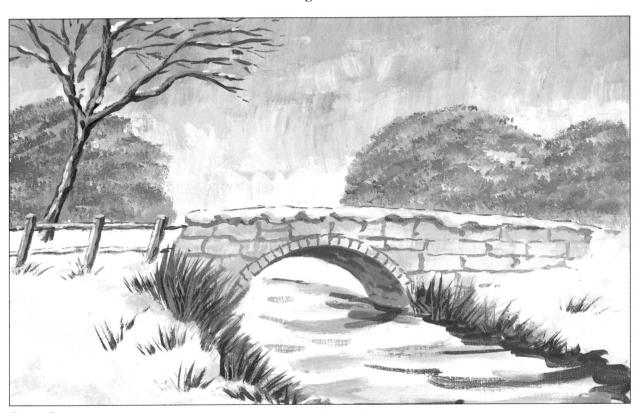

Stage 5

Demonstration 9 Still Life: A Child's Toys

There are lots of interesting and exciting subjects all around us. This colourful selection was found in our child's bedroom. I placed the teddy bear against a pillow and assembled the ball, drum and building bricks to make a triangular composition on the bed.

Stage 1. Sketch the subject.

Stage 2. Build the painting up to the almost finished stage using the methods learned so far, in the previous demonstrations.

Stage 3. The addition of the essential detail is particularly important in the final stage of this painting and the picture should be touch-dry before the detail is added. Pay careful attention to the teddy bear's eyes and nose, ensuring the dark pupils are almost black and the white highlights of the eyes are picked out. A fan brush, or a very dry hog bristle brush, can be used to increase the texture of the teddy bear's fur. Use a darker tone of Yellow Ochre and Burnt Umber mixed into the beige paint on the tip of the brush. Touch and flick the brush to catch the surface of the dry, painted fur using what is known as the dry brush technique seen on page 21.

Stage 2

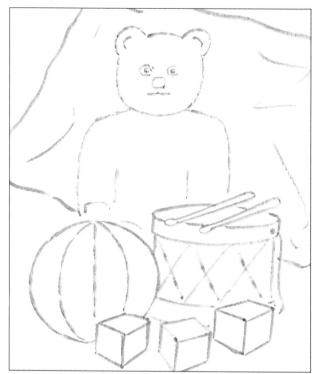

Stage 1

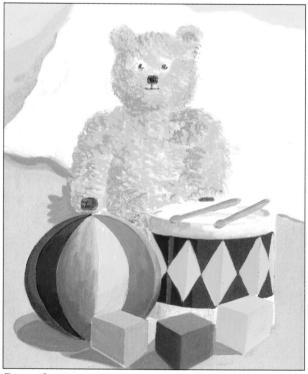

Stage 3

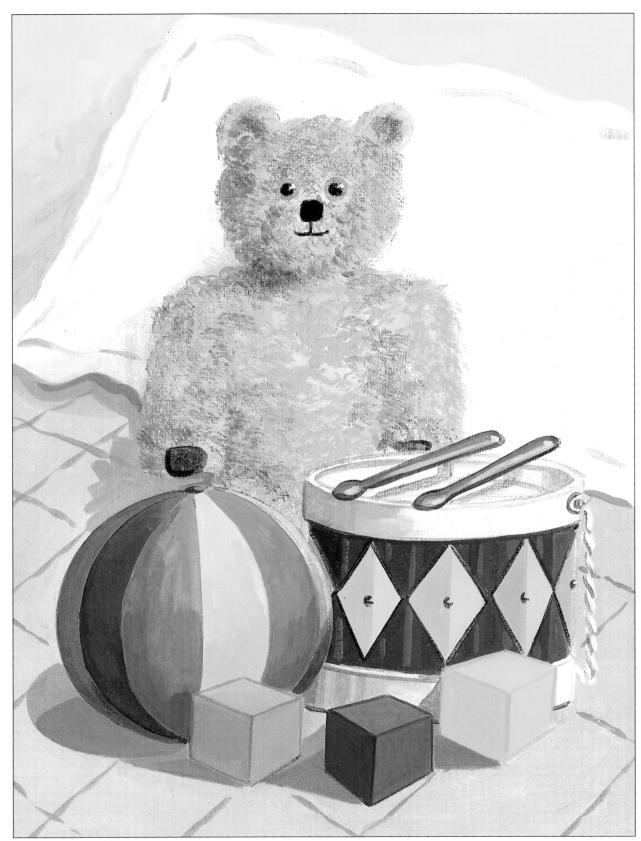

Finished Still Life

Demonstration 10 Floral Study

Most flowers make splendid subjects to paint. If you have a garden, window box or potted plants, you will have some suitable subjects close to hand. If not, you may have friends or neighbours who have some suitable specimens you could beg, or borrow, to paint.

To achieve success in flower painting, start simply, learning to paint individual flowers, ideally from life rather than from photographs. Keep a sketchbook and as the seasons come round make sketches of the individual flowers as they come into bloom. Also make oil painted sketches of the flowers and keep notes about the colourings. By doing this you will come to learn about the makeup, line, form and characteristics of many flowers. This will lead to a confident approach when you decide to paint larger groups and arrangements of flowers.

The technique shown here is an ideal method for the painting of flowers.

Stage 1. Draw the daffodil and tulip and start to block in the main colours. Lemon Yellow with white for the daffodil head, Alizarin Crimson and white to make a pink for the tulip head. Mix French Ultramarine and Cadmium Yellow with white for the stems and leaves.

Stage 2. Mix a little green with the yellow and paint in the shadows on the petals and trumpet of the daffodil. Add a little blue to the pink mixture and paint in the shadows on the tulip head. Likewise, paint in a darker green mixture for the shadows on the stem and leaves. At this point let the study become touch-dry.

Stage 3. Use your No. 3 detail brush and a darker tone of each colour previously used to pick out the detail of the daffodil head, the frilly end of the trumpet, the essential edges of the daffodil petals and the darker edges of the tulip petals. Also pick out any key lines on the leaves. Ensure that the stamens of the daffodil are shown and finally any highlights are clearly identified and painted in.

HANDY HINT. Try sketching and painting three views of individual, real flowers. Paint a front view, a side view and a three-quarter view. It really does help you to understand the construction of flowers.

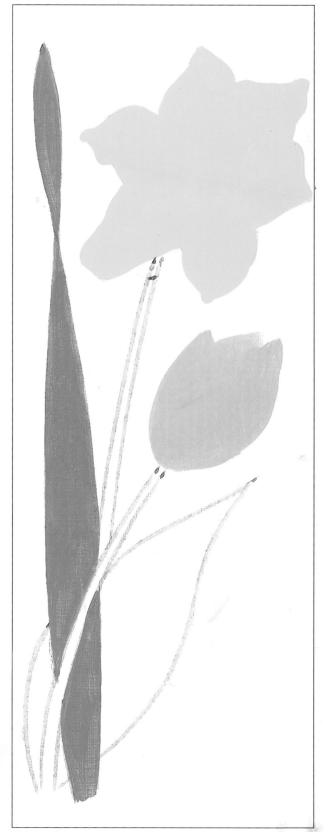

Stage 1

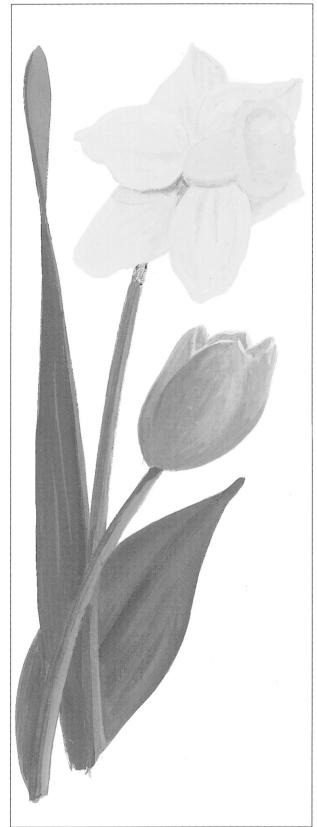

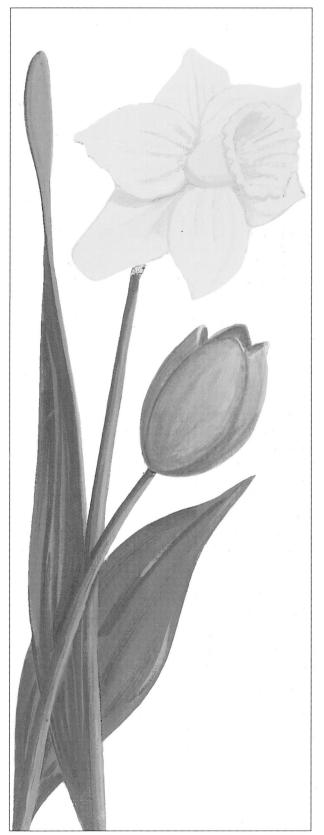

Stage 3

Demonstration 11 The Archer

Whilst on a painting expedition to the Isle of Man I visited Castle Rushen. Amongst the superb tableaux I found this full-sized model of an archer on guard in the guardhouse. I used this subject in my television series and have produced this demonstration for you to try.

Stage 1. Sketch out the archer. Start to block in the grey helmet, Yellow Ochre sleeves, brown and beige tights. Also add the grey chain mail vest showing just below the white sleeveless top. The flesh colour for the face and hands can be made by mixing a little Alizarin Crimson, Yellow Ochre and white. Mix white with a trace of blue and paint in the background walls. Paint in the grey floorboards and window areas. Leave the painting to become touch-dry.

Stage 2. Overpaint each area with their main colours, but concentrating on painting in the light, medium and dark tones for each item and area. Leave the painting to become touch-dry.

Stage 3. Use your fine brush to pick out the details on the face, the decoration and designs of the helmet, white vest, belt, money bag and quiver of arrows, the longbow and arrow. Add the semicircular marks on the chain-mail garment.

Stage 4. Use medium and dark greys for the hint of stonework, windows and floorboards.

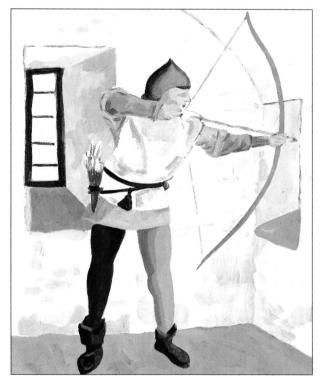

Stage 2

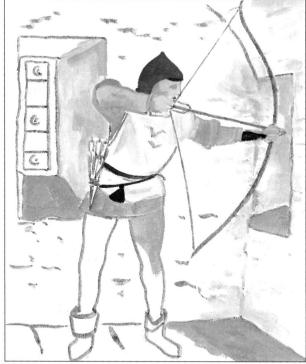

Stage 1

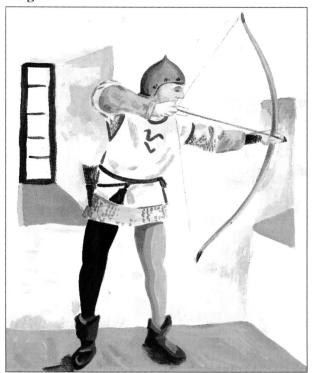

Stage 3

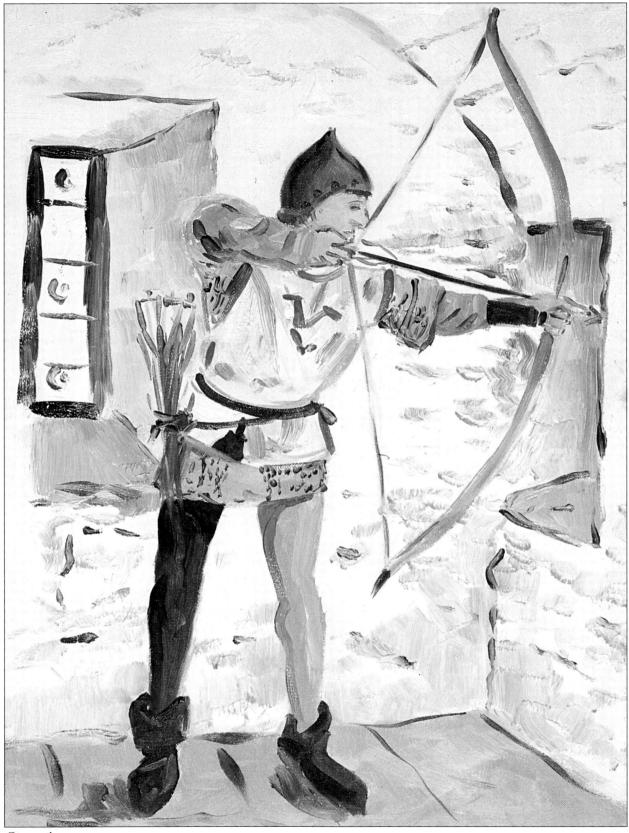

Stage 4

Demonstration 12 "June"

The painting of the foal "June" is a particular favourite of mine. A farmer asked if I would paint her as she was the family pet on which his granddaughters were learning to ride. This was an interesting challenge. There were two main problems. The first, animals do not stand still to be painted. The second, to capture her young look, the size of a foal rather than a fully grown mare. I decided to paint a view looking from slightly above the foal. I made some sketches and colour notes at the farm and walked around the foal shooting a roll of film with my camera from different angles. I then used the original sketches and photographs to sketch and paint "June" in my studio to the nearly finished stage. I took the painting back to the farm. I looked again at the foal, compared her to my painting and added the final details and finishing touches to the painting at the farm.

Try painting "June" in the stages shown here.

Stage 1. Sketch out the foal.

Stage 2. Use a mix of Yellow Ochre, Burnt Sienna and white for the body, head, mane and ears. Use white for the flash on the front of the head. Use a mixture of French Ultramarine and Burnt Umber for the hooves. The nostrils and mouth area can be

painted in blackish-grey made from the previous dark mix with a little white added.

Stage 3. Ensure the light and dark areas on the underside of the body, front of the neck, head and legs are shown. Paint in the eye we can see with your detail brush. The brown leather harness is painted using a mixture of Burnt Umber, French Ultramarine and a little white. This mixture will allow you to achieve the light, medium and dark tones of the leather. The brass rings can be painted using a mixture of Lemon Yellow, Yellow Ochre and white.

Stage 4. The background can now be added. This has been kept simple to ensure the emphasis is on the foal. A greater sense of depth to the field is achieved by placing the distant hedge and tree high up in the picture and by using a light mixture of Cerulean Blue and white for the sky. This is also helped by the light green of the field in the distance and the stronger green and shadow cast by the foal in the foreground.

The greens used for the field were made from a mixture of Cadmium Yellow, Lemon Yellow and French Ultramarine with white. The darker greens were achieved by adding a little more blue and brown to the green paint mixture.

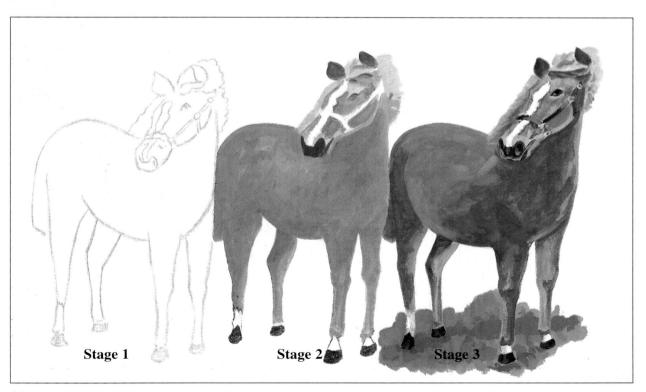

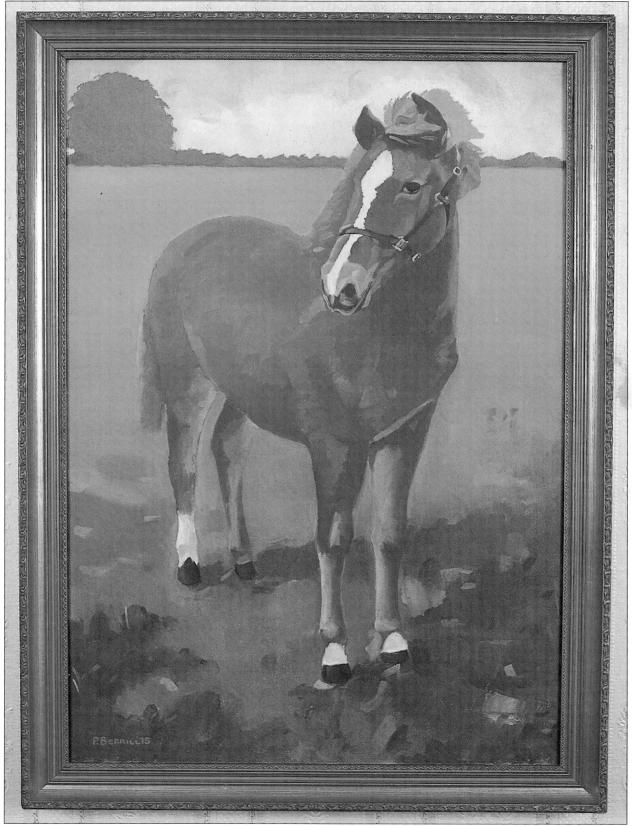

Stage 4

Knickerbocker Glory

Demonstration 13

Venice

Venice has had a profound influence on me as it has on artists, writers, poets and musicians over the centuries. Its magical charm has captivated many of the people who have visited this fine city as members of my painting holiday courses. Venice is liquid light. The effects created by the sunlight and the many varying skies, and by that light being reflected from the water, creates stunning effects during all four seasons of the year. The narrow streets, the canals with their bridges, the gondolas, the open squares, palaces, market and the Venetian citizens, all make for a wealth of paintable material.

The next demonstration is a painting of the waterfront looking from St. Mark's Square to the little island of San Maggiore. This is possibly one of the greatest and best-known views in all Europe. When I painted this, the waterfront was cluttered with a mass of gondolas waiting for the day's tourists to arrive and to glide them along the canals of Venice. I decided to reduce the number of gondolas to enable more of the main view to be seen, and to use the main left and right hand gondolas and the perspective lines of the paving stones to bring our eyes into the main focal point of

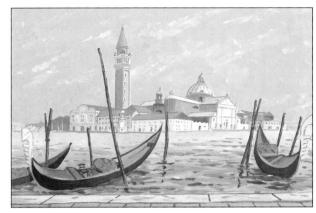

the picture, San Maggiore across the water. I also decided to use the gondola mooring posts to intersect the buildings which in turn helped to link the foreground and the distance; this ensured that the picture was not cut into two equal horizontal halves by the long horizontal bottom line of the buildings.

Stage 1. Draw the subject firmly in charcoal on a canvas or canvas board. Use a dry cloth and vigorously dust off the loose charcoal. This should leave a clear drawing for you to paint your picture on.

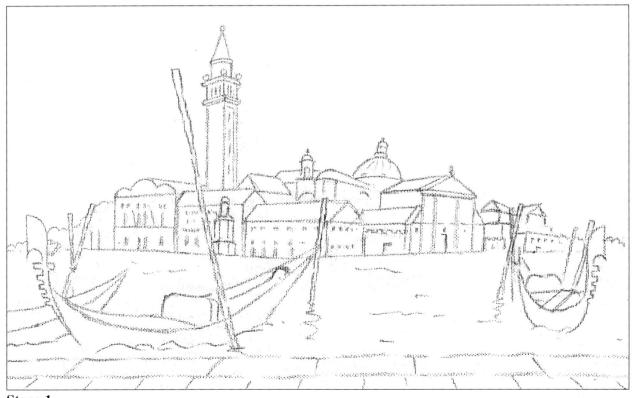

Stage 1

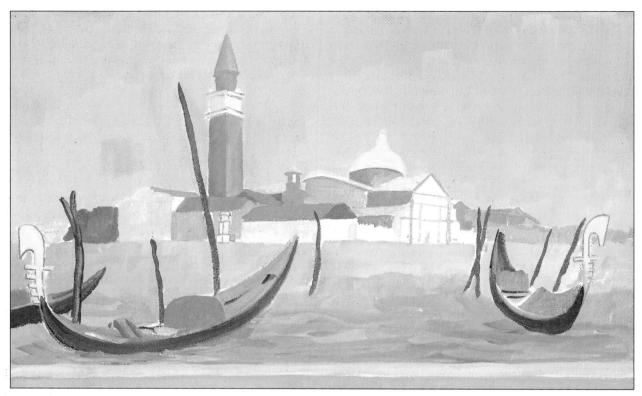

Stage 2

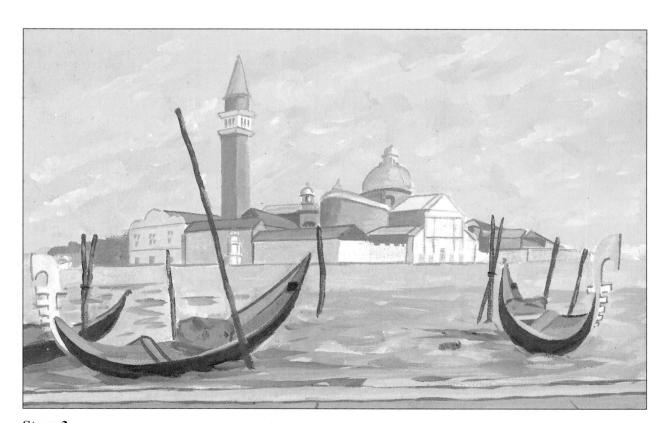

Stage 3

Stage 2. Go to each area or item and mix and paint in an opaque coat of oil paint as near to the colour as you can. Only if the paint seems too thick add a spot of turpentine or painting medium. For the sky use Cerulean Blue and white. For the brick colour of the buildings use Burnt Sienna and white. The white and pale greys of the stone are made by mixing white, French Ultramarine and Burnt Umber. The water is a mixture of white, Yellow Ochre and a little Viridian Green. For the gondola hulls use a black and grey made from French Ultramarine, Burnt Umber, and where needed, a little white. The gondola seat covers are made from white with a little Lemon Yellow and a touch of Viridian Green. The mooring posts are painted using Burnt Umber with a little white, whilst

the paving stones are Yellow Ochre and white with a little Burnt Umber added. The same colours are used throughout the other stages of this painting. Use a No. 10 flat brush for the sky, water and paving stones, a No. 6 flat brush for the buildings and a No. 6 round brush for the gondolas and mooring posts.

Stage 3. When Stage 2 is touch-dry overpaint it with the main coat of paint for each area and item. Stage 2 is the under painting, Stage 3 is the main painting. Re-mix each colour and apply the second coat, also painting in the fleeting clouds and the main water effects as shown in the detail panel. Let this stage become touch-dry. The details are carefully added in the final stage 4.

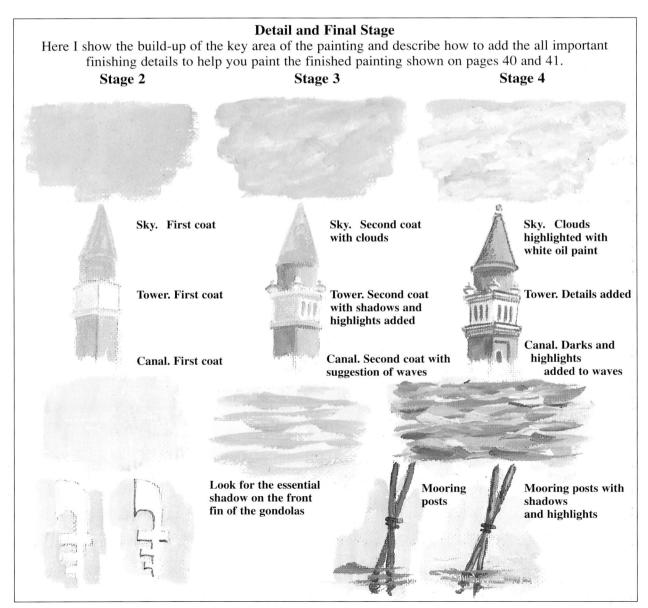

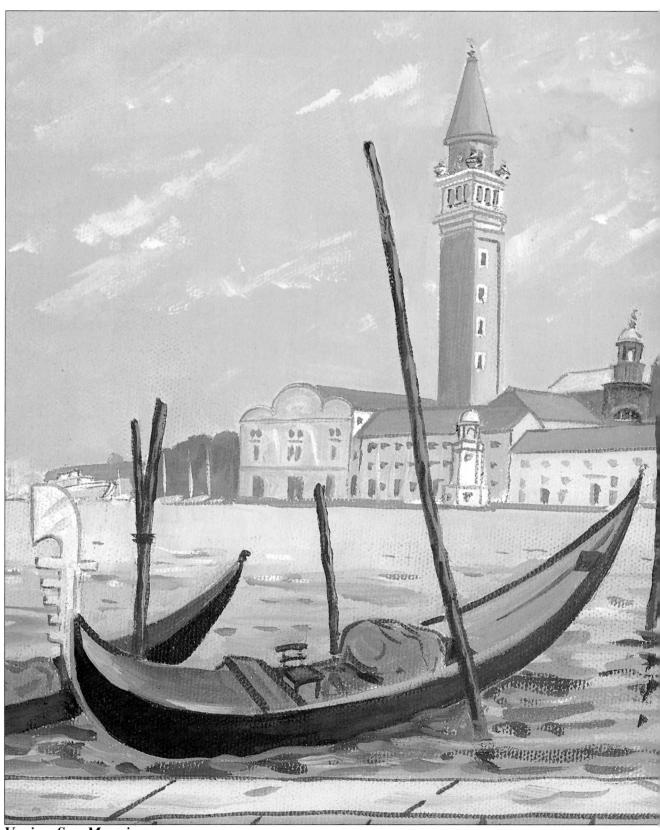

Venice, San Maggiore

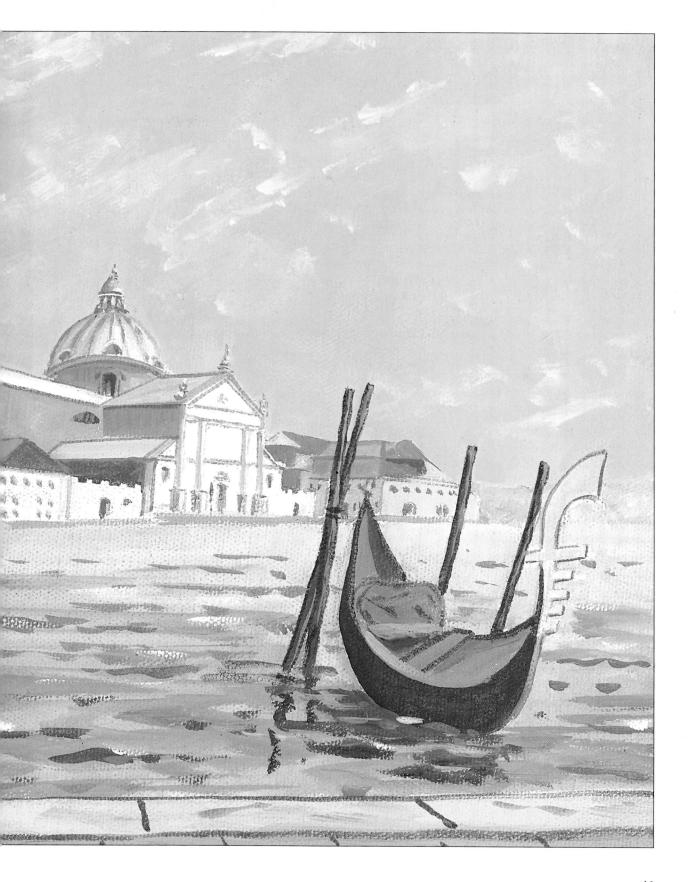

Demonstration 14 Painting from Photographs

Some artists say never copy from photographs, others say it is quite alright to do so. I am often asked who is right. A camera can be an invaluable tool for an artist. The camera and photographs can be a means to an end, but should not be an end in themselves.

When I go out sketching I usually take my camera with me. A combination of sketches with the back-up reference of photographs provide all that is needed to produce one or more paintings in the studio. Sometimes if outdoors, or on holiday with family and friends, I see a subject I would love to paint but there is not even time to make a sketch. The camera provides a quick snapshot of the subject for later use.

If a person is housebound, photographs can provide a regular source of material to work from. Do not however copy the photograph slavishly. Let your own style and interpretation of the subject come through in the painting.

You will often find a subject within a subject. Below I show a photograph of a Scottish harbour. I also show, on the opposite page, three boxes or sections that could be taken from this photograph as pictures in their own right. This offers you the choice of painting the whole view, or any one of the three segments, in the way shown in my finished painting opposite.

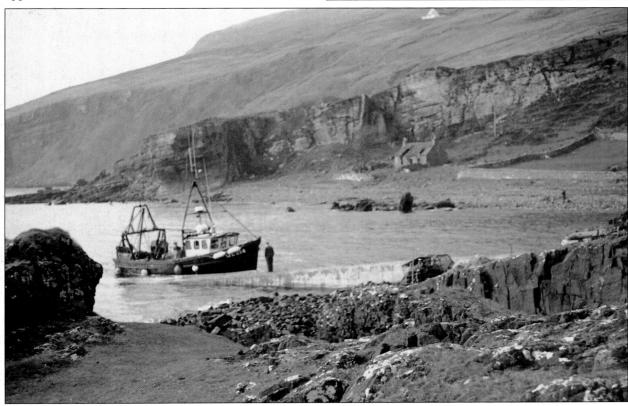

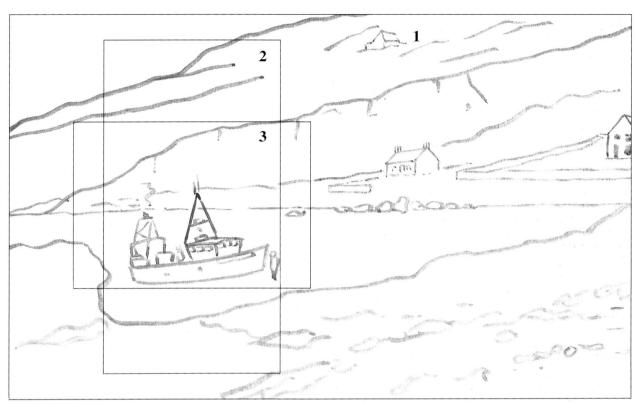

Three possible views

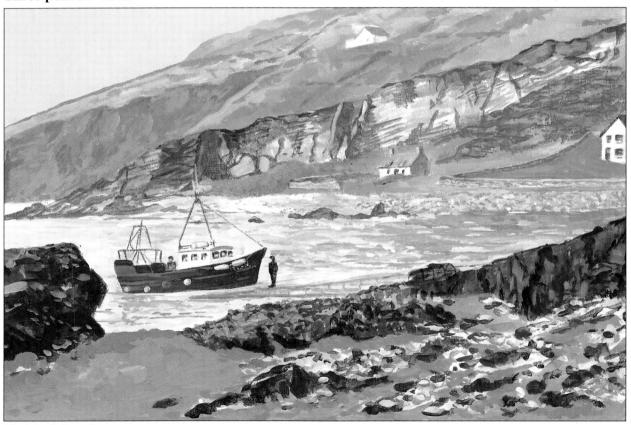

Finished Landscape

Demonstration 15 Painting Out-of-Doors

Many people think oil paints are not a suitable medium for outdoor use due to the wet, sticky nature of the painting. It can be practical, if you have a car, to transport the wet paintings and your equipment to the location and back. Some art stores sell canvas carrier devices for holding wet oil paintings. But if you are on holiday, or do not have a car available, there are two practical methods I use for outdoor oil painting and which could be of help to you.

Method 1. LIQUIN

Winsor and Newton produce Liquin, an alkyd resin, that you can mix with your oil paints instead of turpentine or linseed oil for normal oil painting techniques. It accelerates the drying of the oil paint. I use it frequently. If I am on holiday and use Liquin to mix with my oil paint when painting at the beginning of the holiday, the pictures are touch-dry at the end of the holiday and can, with care, be transported home safely. Gryffin Alkyd paints are synthetic paints similar to oils but based in alkyd resin. They are normally touch-dry in about 18 hours. More details can be found about these paints on page 58.

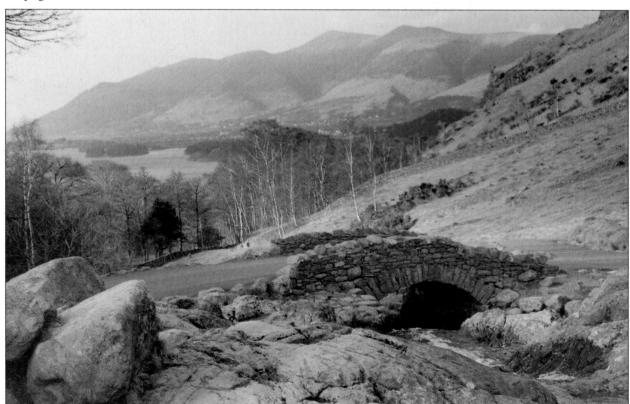

Photograph of painting location

Method 2. The Tinted Canvas Panel

On the page opposite is a photograph I took at the location where I painted my tinted canvas panel. I chose my final viewpoint more to the right so that it included more of the fast running stream.

Stage 1. Take a canvas panel, your oil paints and materials out with you, making sure you have some clean turpentine. When you find a subject that appeals to you, sketch it out in charcoal on the canvas panel.

Stage 2. INSTEAD of using your oil paints thickly, as normal, do the opposite. Mix the paint thinly and tint the various coloured areas of the subject, or view, with a thin tint of its own natural colour.

Stage 3. With care, the light, medium and dark tones of colour for each part of the subject can be thinly applied. The result will have an almost water colour painting look to it. In 30 to 60 minutes the turpentine will have evaporated and the panel will be dry. You can then take the panel home. On cold, wet, winter days, or dark evenings, sitting in the comfort of your home or studio, take the panel out and paint the fully finished oil painting on top of your original, tinted oil colour panel.

HANDY HINT. Don't forget to take a sun hat if going painting outdoors on hot summer days. Also take some insect repellent. There is nothing more frustrating than trying to paint and being bothered by airborne insects.

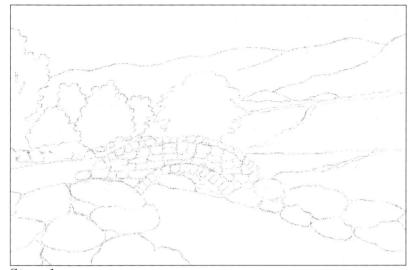

Stage 1

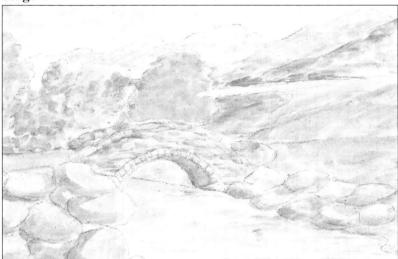

Stage 2

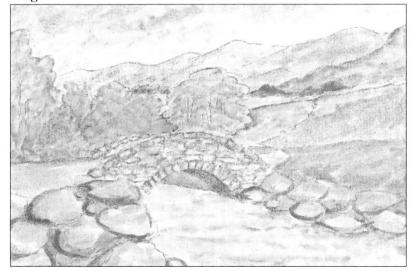

Stage 3

Demonstration 16 Portrait

Many people who take up painting quite soon find they produce some very good quality work and have an urge to try a portrait. Some people will have a natural flair for portraits and others will find it more of a challenge. My advice is to avoid painting members of the family and children until you have gained expertise in painting character faces. People over the age of 25, particularly older people, often have lines of character and distinctive features which provide the best subjects to practise on. After gaining experience on these types of faces, family faces can be tried. Beware, every member of the family will be an instant critic. The difficulty in painting children, with their very smooth complexions, is trying to convey accurately the age of the young person. This is challenging but can be achieved with practice.

In the portrait demonstration I used as my model a rugged looking local builder. I always make a number of quick pencil sketches to decide on the best view: full face, profile, or as here a three-quarter view.

Stage 1. Sketch the face using the charcoal drawing method.

Stage 2. Paint the face and neck using a medium flesh tone made from a little Yellow Ochre, Alizarin Crimson and white. The hair is a mixture of Burnt Umber, a little Yellow Ochre and white. The shirt is

blocked in using Cerulean Blue and white. The lumber jacket Yellow Ochre, Burnt Umber and white.

Stage 3. Mix a little Alizarin Crimson with the flesh colour used in Stage 2 for the cheeks. Add a little French Ultramarine and Alizarin Crimson to the flesh colour for the jaw and shadow on the neck. Sometimes the addition of a very small amount of Viridian Green to the flesh mixture can make a good flesh shadow colour. Pick out the lighter and darker tones of the hair. Allow the painting to become touch-dry.

Stage 4. Using your No. 3 round detail brush add the eyes with a pale blue and a bluish-black mixture for the pupils. Use Burnt Umber with a little blue added to paint in the eyebrows, nostril, and moustache. Add a darker flesh tone for the shadow under the lip. More detail can be added to the shirt and jacket. Do not however let the detail in the clothes dominate the face.

HANDY HINT. Practise making lots of quick, 10-minute, pencil portrait sketches in your cartridge sketchbook. By putting a time limit on each one you learn to pick out the essential lines and aspects of the face.

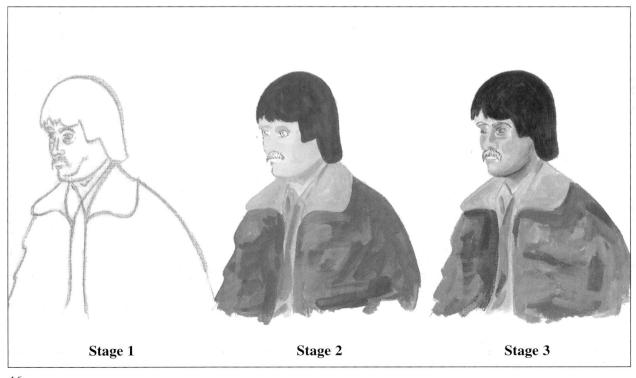

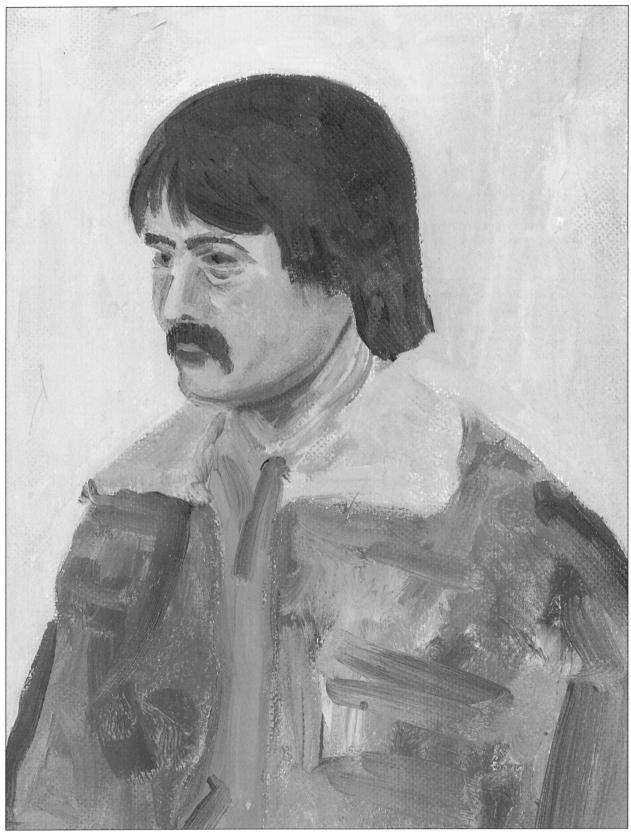

Stage 4

Composition

The sketch or drawing of the subject you are going to paint, the skill in your colouring of it, the illusion of the textural effects, use of light and shade are all important elements of your painting. Another aspect equally important and which I come to now, is the composition of a painting.

There are certain guidelines, that if followed, can help you build your work on sound compositional foundations. One of the most important things to avoid is having any line or object that cuts your picture into two equal halves, as in view A below, where the horizon is half-way and so divides the picture into equal horizontal halves, and in view B, where the tree trunk divides the view into two vertical halves. Set any such line or object to one side or other as in C and D. The horizon is just below half-way and the tree trunk to the right of half-way.

View A

View B

FOCAL POINTS AND KEY LINES

Decide what it is that you want the person looking at your painting to look at in particular. The eyes should not be left to wander as if the viewer is lost. You are the artist, you are in control, be decisive.

A picture should have a FOCAL POINT, that is, a main feature to which the eyes are led. I show three views. In E, the Focal Point, the cottage, is in the middle distance, in F, the Focal Point, the ship, is in the far distance, and in G, the fisherman in the foreground is the Focal Point.

A picture should also have KEY LINES of the composition leading the eyes of the viewer to the FOCAL POINT. I have arrowed the key lines of the three compositions and I think from these illustrations you will see how the use of the Focal Point and Key Lines help bring a composition together.

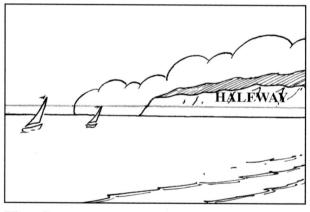

View C

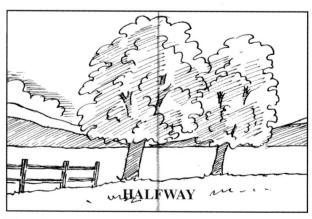

View D

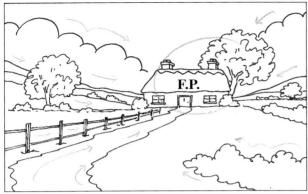

View E

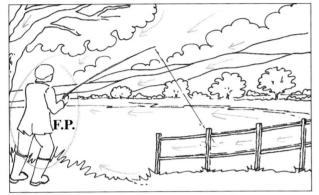

View G

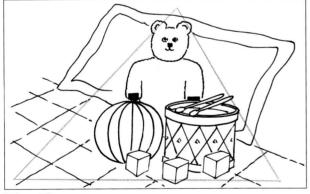

View H

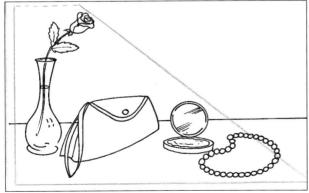

View I

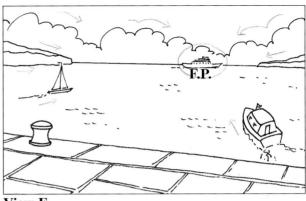

View F

THE TRIANGLE

Very often a triangle can offer an excellent shape on which to base a composition, especially a still life or floral study. In the three illustrations H, I, and J, I show this at work. In H, I have a still life made up from a group of toys. I have placed the teddy bear to the right so the apex of the triangle is off-centre. In I, the rose in the vase forms the upright of the triangle, with the handbag and powder compact forming the base. In J, the tree creates the triangle's upright side, with the landscape and church forming the bottom and third, sloping side, of the triangle.

Try to ensure that still life and floral studies have height, width and depth to them.

If you now go and look at paintings, or prints of paintings, by any of the great masters, or by any fine artist of today, you will almost certainly find that their most successful paintings employ many of the important compositional points I have referred to here.

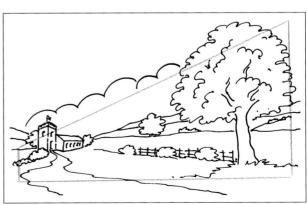

View J

Perspective

Perspective is the one area of drawing and painting in which most people experience some degree of difficulty. When most people hear perspective mentioned they go to a bookshop or a library, obtain a book on the subject, flip through it, see lines shooting about all over the place and usually end up more confused than before they opened it. The secret is to keep the whole business of perspective as simple as possible, to remember a few basic rules, and to bear in mind that perspective is not something one masters all in one, two or three lessons. Learning about perspective is an on-going learning process. One goes along over a period of months, indeed years, collecting together the pieces of information, like pieces of a jigsaw, until they all fit together and the picture, the theory of perspective becomes clear and easy to apply to more advanced than men in relation to colour, colour harmony and colour balance. I am pleased to say with the introduction of teaching technology to girls as well as boys at school this should change in the future.

The eyelevel is an imaginary line, horizontally across your field of vision when you look straight ahead, not up, nor down, but straight ahead. In my sketch I show a figure sitting low down, as if on a beach, then standing, then standing on a sand dune. Note how the eyelevel is always directly ahead of the figure. When looking at a real subject look straight ahead, hold a ruler straight out with the thin edge in front of, and across your eyes, and that is where your eyelevel is. Which comes first, the drawing in of the eyelevel or the object? Generally I suggest you draw in the object lightly first, then

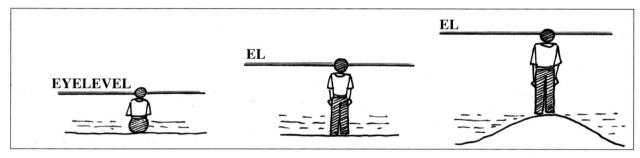

one's work. Most men used to have an advantage over the ladies when taking up drawing and painting, because at school most boys learned basic carpentry and even some metalwork. Some boys were taught basic technical drawing, and on leaving school and entering a working life the types of books, manuals and journals they read had line

apply the eyelevel and use it with the rules of perspective to check and correct the object.

One way to see perspective in action is to picture the view looking along railway lines. They appear to merge in the distance. They appear to become smaller and closer together. The point where they appear to merge is known as the 'Vanishing Point',

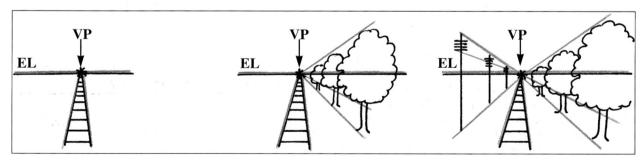

drawings, plans, front elevations, and side elevations of all sorts of subjects in them. It is this basic familiarity with line that is very handy when learning to paint. Most ladies don't have that background experience, so I often find ladies at first need extra help with drawing. However, because of their knowledge from an early age of fashion, make-up and colour schemes I find ladies are far

V.P. We know they do not merge in reality. I show this in my sketch. I also show the railway lines with telegraph poles on the left, then with three trees on the right. The telegraph poles and the trees in a drawing or painting would also appear to become smaller and closer together as they recede. I have shown the guidelines for each item, illustrating how the guidelines all meet at the Vanishing Point, V.P.

Next, I show a front view of a television. With this view, we have just one vanishing point for the sides of the television and for the baselines of the legs. I am imagining that you, or I, would be sitting on a normal chair of a standard height when drawing this television, in which case, I think you would find your eyelevel would be just about 18" (450mm) above the back of the television. In my next sketch the television is set at an angle. Now we have two vanishing points, one for each side of it. Often guidelines want to converge on the eyelevel, but off the page. This is normal, and often happens. When it does, lay scrap paper at the side, tape it on from behind, and extend the guidelines onto it, in the way

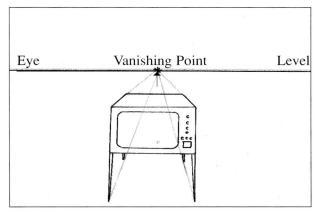

Television

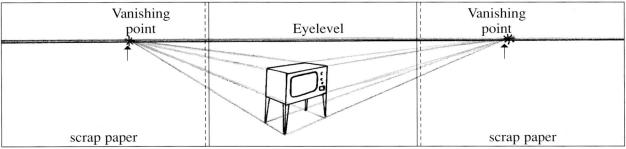

I show in my sketch. Never guess or assume the perspective is correct, always try to 'prove' it.

Circular Perspective. Few people realise that perspective can be used to help solve the problems of drawing circles and ellipses, but it can. I have illustrated this in a sketch of three saucepans with one on its side. I have lightly drawn the group out and have placed my eyelevel well above it. I have then drawn a light guiding square around each ellipse we can see and have drawn those squares 'in perspective', in the same way as the television has been drawn. The squares for the ellipses each have their respective vanishing points on the common eyelevel. The two upright pans share the same vanishing point as their ellipses are on the same plane. The ellipses for the pan on its side are on a different plane so have their own vanishing point at a different position on the eyelevel. The use of the squares helps determine where each vanishing point should be, to ensure the true perspective of the subject where there is an ellipse involved. I then go back to each ellipse and check it touches the centre of each side of the square it occupies, for provided it does, I know the ellipse must be in perspective. The squares used outside of each ellipse and perspective guidelines can be rubbed out gently before a picture is shaded in or painted.

Television at an angle

Barn at an angle with 2 V.P.s

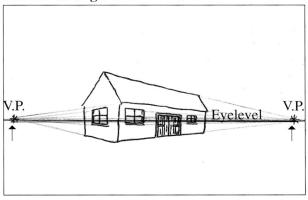

Circular perspective. Saucepans

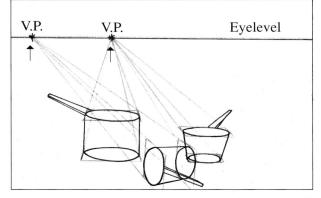

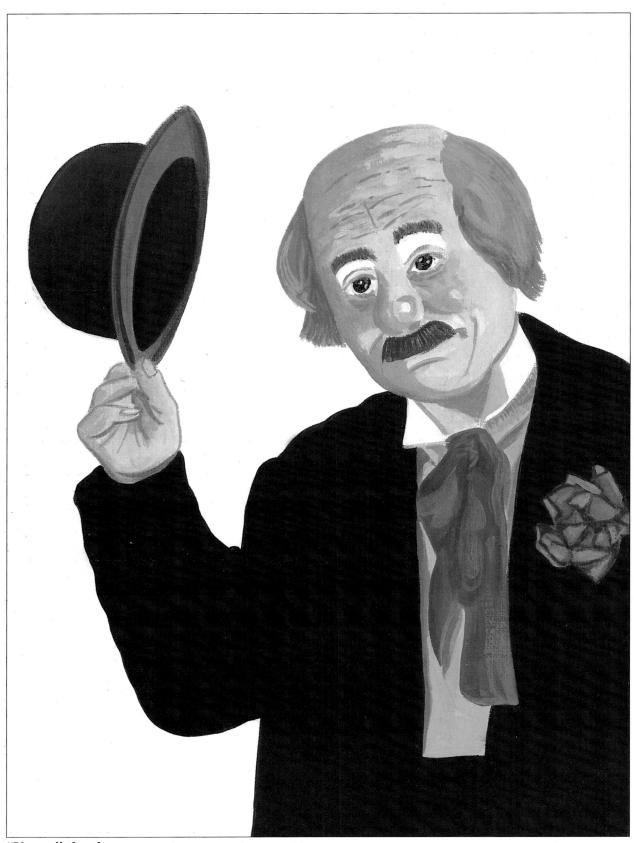

"Vercoe" the clown

Demonstration 17 Abstract and Fun Pictures

Above all else painting should be fun. Whilst most people wish to learn to paint pictures in the traditional manner, others like to experiment and explore other ways of expressing ideas in paint. I painted the clown for a young child. It gave the youngster a colourful picture to hang in her bedroom and it was fun to paint.

Pictures that have no easily identifiable subject, or paintings exploring abstract ideas can be confusing to many people. They can however provide ways for an artist to try to convey thoughts and abstract concepts in paint. Play with the following three abstract picture techniques.

- 1. Take a line for a walk. Draw a long line, criss-crossing it on the painting surface. Mix and use different colours of paint to fill in each segment. When dry, outline with a fine black line if you wish.
- **2. Hard Edge.** Try drawing simple geometric forms, painting them in colours that appeal to you.
- **3. Action Painting.** Create an inky consistency of yellow, using turpentine and oil paint, on an old saucer. Pour blobs of the liquid yellow oil colour onto your painting surface. Tip the painting up vertically and tip it from side to side so the colour runs around. Let it dry. Repeat with red, let it dry. Repeat with blue.

Abstract Hard Edge

Abstract "Colour in"

Abstract "Action"

Demonstration 18 Palette Knife Painting: Making Your Mark

Palette knife painting is a technique well worth exploring. There are two main groups of knives.

The palette knife is a long, straight, finger-like, metal blade fixed into a wooden handle. The metal is a little thicker than for the painting knives. The palette knife is used essentially for mixing oil paint on your palette. Plastic palette knives are also obtainable. Palette knives can be used to apply paint to the canvas and to paint with as well as for their main purpose of mixing colours.

The painting knives come in a wide range of shapes and have a cranked handle. This helps ensure your fingers do not touch the painted surface when applying the paint. The metal for the blade is thinner and more springy. A wide range of different marks can be produced by changing the pressure you apply to the painting knife.

When selecting your first painting knife, I would recommend a medium, trowel-shaped knife which is perhaps the most versatile.

The oil paints are usually used directly from the tube and mixed together on the palette with no medium added. If the paint is too stiff a little linseed oil or Liquin can be mixed into the paint. If the tube paint is too runny, squeeze it onto some blotting paper for an hour or so, this will allow the surplus oil to escape from the oil paint before you transfer it to the palette.

Be generous with the amount of paint you use. You want to achieve a good texture to the paint layer. This textured look is known as 'Impasto'. Whilst palette knife paintings use lots of paint, it is better to paint one or two subjects with plenty of paint than several by trying to economise with the paint. Apply the paint to the picture surface and create shapes and texture marks in the wet paint with the knife. Do not allow any area you are working on to dry and then add more paint on top of that with a knife. It is rather like trying to ride a bike on a bumpy road. Work into the existing wet paint if adding other colours or effects.

Palette knife paintings are best seen from a distance of several feet, or metres, away. It is wise to keep standing back to assess the painting's progress.

On the page opposite you will see a wide range of marks and effects achievable with a palette knife and a painting knife. Experiment using the tip, half

and full blade, and edge of your painting knife to see how many different effects and marks you can make.

HANDY HINT. Although palette and painting knives are usually made from stainless steel, I recommend you wipe them clean, wash them with a little soap and water and dry them thoroughly after use.

Some of the palette and painting knives

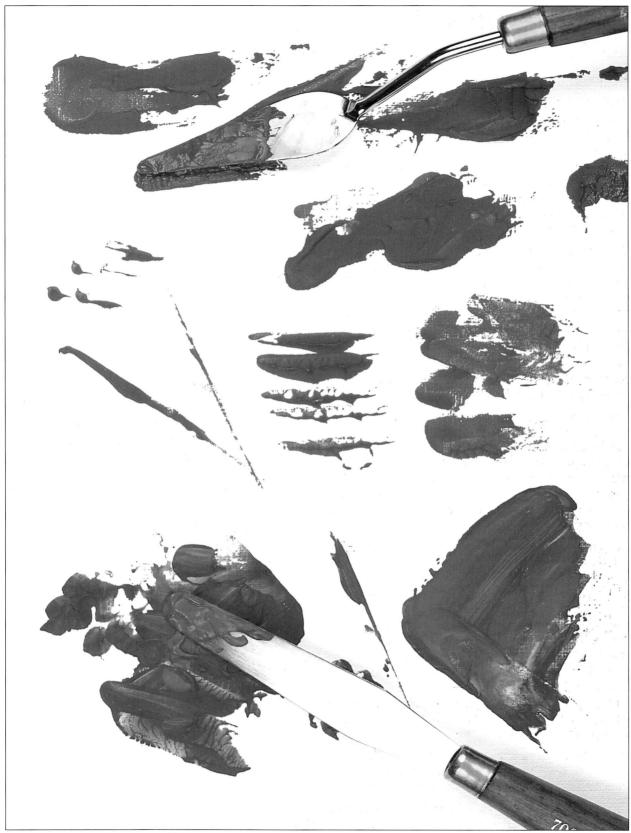

Palette knife marks and effects

Demonstration 19

A Sunset Painted with a Palette Knife

This dramatic subject is designed to help you twist and turn the wrist of your painting hand and to use a variety of painting knife marks to arrive at the finished painting. The knife techniques acquired can then be used on other subjects.

Stage 1. Whilst your subject can be drawn prior to painting, on this occasion try the demonstration without drawing it out. Squeeze out onto your palette a generous amount of white, Cadmium Yellow, Alizarin Crimson, French Ultramarine and Burnt Umber. Load the end of the painting knife with white and make a small circular shape for the sun. Mix white and yellow together. With a well-loaded knife make wide knife marks of yellow, as if radiating out from the sun, as shown. Let the yellow become deeper at the outer edges.

Stage 2. Mix red, yellow and white together to make orange. Apply this, with the Alizarin Crimson added later, to the outer areas, spreading from yellow to orange into Alizarin Crimson.

Stage 3. Add the reflected sunset in the lake in exactly the same way.

Stage 4. Mix a light tone of reddishmauve using Alizarin Crimson, French Ultramarine and white for the silhouetted clouds and for the distant hills. Mix a medium tone of the same colour for the nearer hills and a darker tone for the nearest hills. Increase the amount of red and blue in the paint mixture to achieve the darker hill tones. Now repeat this for the hill reflections in the lake.

Stage 5. Make a very dark mix of deep mauvish-brown from Burnt Umber, French Ultramarine and Alizarin Crimson. Load the knife with the darker colour and work with the thin edge of the knife turned to the surface of the picture. This should enable you to twist and turn the knife to place the medium and thin lines for the tree, fence and foreground grasses. Clean the knife and load a little bright yellowish-orange on the side and tip of the knife. Touch on the sunlit highlights to the tree trunk and branches. Add the three birds and your painting knife picture should be finished.

Stage 1

Stage 2

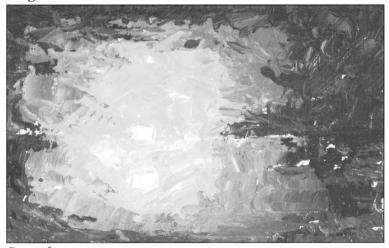

Stage 3

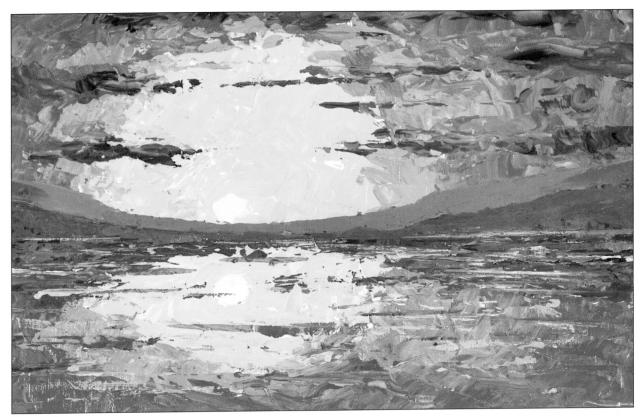

Stage 4

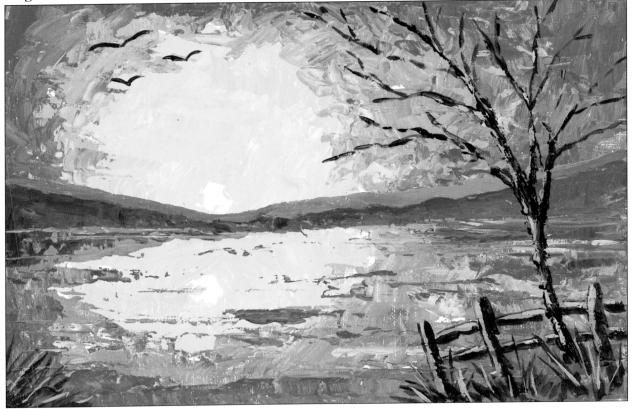

Stage 5

Gryffin Alkyd Paints

Griffin Alkyd paints are perhaps one of the least well known of paints available to the artist. Although they have been on the market for several years many artists are still unaware of their excellent properties and advantages. Not to be confused with the water-based acrylic paints, Alkyd paints are pigment bound in a synthetic, alkyd resin base. They behave just like oil paints but with one major advantage. The paint is normally touch-dry in around 18 hours. Liquin, the alkyd resin I have referred to in earlier chapters of this book, is used to mix with Alkyd paint. If you like to overpaint areas of your painting, use glazing and scumbling effects, or if you like oil painting on holiday, this is a splendid paint for you. It enables you to work on the dry surface next day, instead of in several days' time. It also means that you do not have to struggle home with wet, sticky paintings from a painting holiday. I painted the picture of the Island Fort at Marmaris, Turkey, using Griffin Alkyd paints. The colours are stable and light fast and the paint has been rigorously tested by the manufacturers.

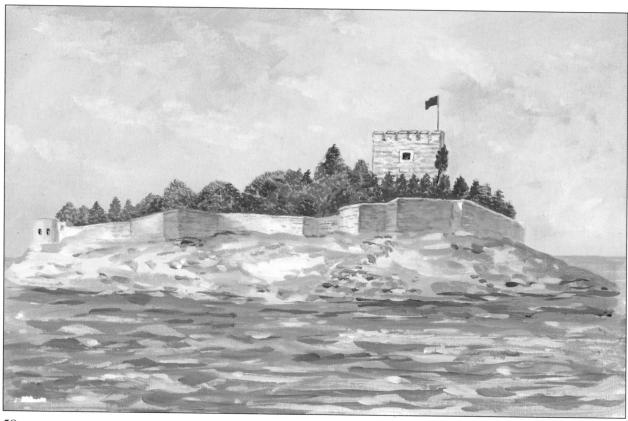

Demonstration 20 Glazing and Scumbling

If you are familiar with water colour painting, you will know how one translucent layer is laid on top of another which helps achieve some of the characteristic effects of that medium.

Thin, translucent layers of oil colour can also be brushed over a previously dry layer of oil paint. The thin wash tints the underneath painted area. The thin mix of colour can be made by mixing extra linseed oil and turpentine to the oil colour to be used for tinting.

If a light tint is applied over a darker colour, it is known as a GLAZE. If a dark tint is applied over a light colour, it is known as a SCUMBLE. As the oil/turpentine mix can take several days to dry before other tints or work can be carried out, it can be a lengthy process to arrive at the finished effect. If you make the colour tint using Liquin, it can be applied over dry oil paint and the tint is touch-dry next day. If you use Griffin Alkyd paints for the whole picture, the opaque paint layers and the glazes and scumbles will all be touch-dry around 18 hours after they are applied. For those artists who like to add glazes and scumbles this is a major advantage.

The simple demonstration panel shows how to familiarise yourself with the properties of glazes and scumbles.

A. Paint three long brush strokes, red, yellow and blue. Leave a space between them. Let the paint dry. Mix each colour with Liquin on your palette. Apply three more brush strokes using the translucent red, blue and yellow at right angles as shown. Let them dry. Note the effect of the glazes and scumbles.

B. Paint the piece of wood illustrated using Burnt Umber, French Ultramarine and white. Let it dry. Mix a thin glaze of Burnt Sienna and Liquin. Brush the translucent colour on top of the left-hand half of the wood. When it is dry compare the two halves.

C. Paint a tonal grey apple. Let it dry. Apply a thin glaze of Yellow. Let it dry. Apply a thin scumble of green, leaving part of the left side the original yellow. Let it dry. Apply a thin scumble of darker green on the right side. Let it dry. Add the shadow the apple casts. The apple will have been created with glazes and scumbles on a grey background.

With practice and imagination you will find situations when painting in oils where you can use glazes and scumbles to good effect.

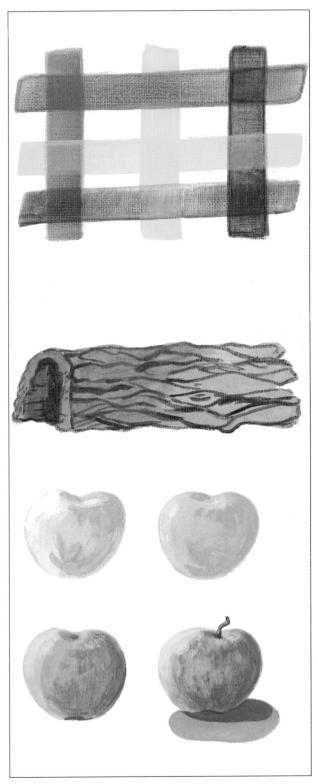

Demonstration 21 Oilbar

Oilbar is an innovative and exciting dimension in artists' oil colours. Developed by artists for artists Oilbar opens up a new opportunity for picture making and artistic expression. There is a range of 35 colours in three sizes known as stump, original and slim. The freedom to work directly onto the painting surface, in the same way as with charcoal or pastel, opens up all sorts of possibilities.

The colours can be applied direct to the surface of your painting support. They can be used to draw with, one colour can be rubbed with another to create blended coloured effects. The sharp point of a craft knife blade, or a pointed or chisel-edged piece of wood can all be used to scratch through one colour to the colour beneath for a wide range of effects. They can be blended with a brush using a little linseed oil to achieve other effects. They are quite simply as versatile as your imagination.

When asked for ideas for your birthday present or special occasion present, this is the ideal opportunity to ask for a set of Oilbar.

Try out the effects described above and shown in the right-hand panel on this page.

Now try the Zebra demonstration.

Stage 1. Sketch the Zebra with charcoal. Use black and white Oilbar to fill in the stripes, blending the white stripes with grey as they come round and down the Zebra, into shadow.

Stage 2. The background scrubland and distant greens are a blend of Yellow Ochre, Burnt Umber, Oxide of Chromium and white. The sky is a blend of Cerulean Blue and white.

HANDY HINT. The picture can be varnished after about six months. Use a coat of Oilbar Isolating Varnish. 24 hours later apply a coat of Oilbar finishing varnish.

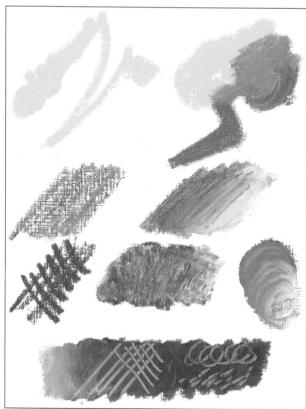

Oilbar marks and effects

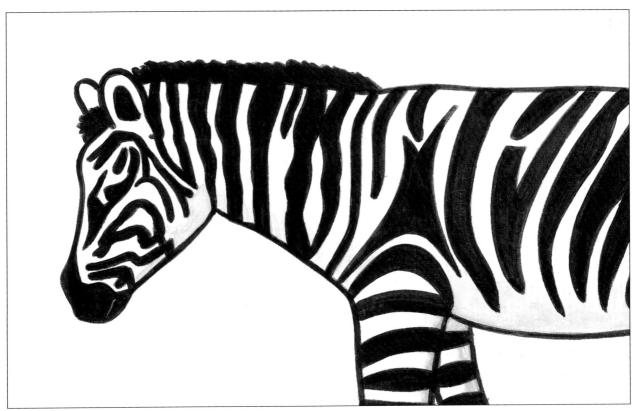

Stage 1

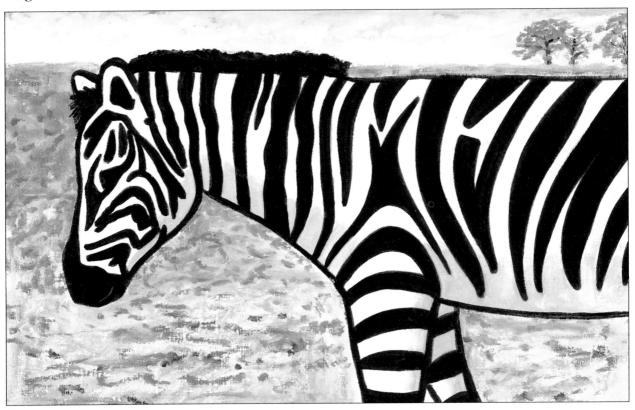

Stage 2

Varnishing and Framing Oil Paintings

Allow at least six months for your painting to become thoroughly dry. During this period it will appear to lose some of the richness and sheen of the fresh oil paint. This will be regained when the picture is varnished. The varnish also acts to protect the surface of the painting from the atmosphere, as normally oil

paintings are not framed under glass.

You can apply either a gloss varnish or a matt varnish depending on your preference. The gloss varnish brings back the richness of the original colours. Gloss varnish comes either in bottle or aerosol cans. The matt varnish comes in bottles. Lay the picture on a newspaper-covered table. Pour the bottle varnish into a clean dish and using a large, flat, clean, bristle brush apply the varnish from top to bottom. The picture should remain flat while the varnish is drying.

Alternatively you can spray the picture with an aerosol of picture varnish. Spray a light coat left to right, top to bottom and the next day spray a second

coat, but at right angles to the first coat.

Frames can often be bought ready-made or can be tailor-made by a picture framer. The choice of picture frame is a very personal one. It will depend on what you feel looks right for your picture, or where it is going to hang. A good local picture framer will often be pleased to offer you the benefit of his experience and show you a selection of mouldings he feels could be right for the painting. For those artists who like to make their own frames, suitable mouldings can be found in many D.I.Y. stores.

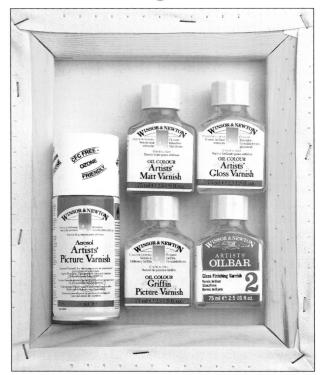

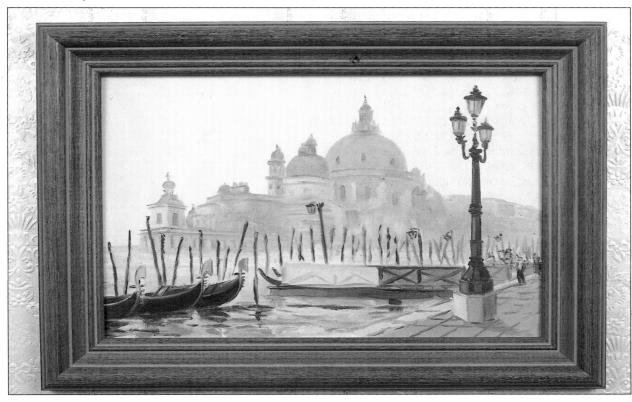

Exhibiting and Selling Your Work

Most people like to keep their first paintings or give them to family or friends. As the standard of your work develops start to consider the opportunities to exhibit and sell some of your work. I would certainly recommend that you consider joining a local art club or society. Local art galleries and libraries usually have details of such groups. You will often find that helpful support, friendship, visiting artists demonstrating their techniques and the opportunity to show in the group exhibitions will all be available to you.

The local libraries and art galleries will usually have details of forthcoming local, regional and national exhibitions and even painting competitions. There are a number of good monthly art instructional magazines available from most newsagents. The magazines not only give advice and help, but often list regional and national exhibitions.

Exhibitions can vary from pictures hung on street railings to seeing your work hanging on the walls of The Royal Academy or other famous institutions.

Local high street stores, restaurants and building societies will often be willing to take and display your work in their buildings or windows, usually on a sale or return basis. It is customary to offer a percentage of any sales to the establishment.

Most towns and cities will have open exhibitions. Work is usually submitted by artists in the vicinity. As more work is usually entered than there is space to hang, a selection committee will choose the work to be hung. If your work is accepted it is an exhilarating feeling. If work is rejected many people find it dispiriting. It should not be. Due to lack of space very good work is often rejected. It might be that they already have several similar pictures to yours, and just by bad luck yours was not one of the earlier paintings viewed or it would have been selected. Work sometimes rejected by one exhibition will be accepted by another.

You can always mark your paintings 'NFS', Not For Sale, if you want to display but not sell them. If you decide to offer work for sale and are uncertain of the price to charge, a local framer or senior member of an art gallery, will usually have a knowledge of current prices if asked.

Do keep copies of the receipts for the art materials and frames you buy and any expenses you incur and sales you make. This is in case you find your income from such sales is taxable.

Copyright. It is an infringement of copyright to copy and sell a living artist's work, or during the period of 70 years after the artist's death. Many artists, especially art tutors and artist/authors like myself, have no objection to students copying paintings as

one of the means of learning the art of painting. The techniques and skills you learn should, ideally, be applied to your own original subjects for exhibition and sale.

PICTURE SHAPES

Experiment. Most painting supports are rectangular. Many artists just paint their pictures filling the traditional rectangular shapes, either horizontal or vertical.

It is possible to buy other shapes of canvas, canvas boards and frames. These can make for exciting picture compositions and are usually very welcome in art exhibitions, yet few artists think to use them.

Apart from the regular rectangular shapes try

Apart from the regular rectangular shapes try painting some of your own pictures on supports made or cut to the shapes below.

OIL PAINTING

is one of a series of art books which we hope you find helpful, enjoyable and informative.

The first four titles in the series are:

Everyone's Guide to ... WATER COLOUR PAINTING Everyone's Guide to ... OIL PAINTING Everyone's Guide to ... PASTEL PAINTING Everyone's Guide to ... SKETCHING

These titles are available from bookshops and artshops or can be ordered direct from:

B.B.C.S. P.O. Box 941 North Humberside HU1 3YQ England

Philip Berrill
"The Flying Artist"

News Letter

If you would like to receive copies of Philip Berrill "The Flying Artist" Newsletters giving details of his demonstrations, talks, roadshows, painting holidays, videos and other interesting news please write to:

PHILIP BERRILL "THE FLYING ARTIST" PO Box 39, Southport England PR9 9JA

Some helpful Do's and Don'ts

- 1. Do make out the colour charts on pages 14 and 15 and keep them by you when painting.
- 2. Do try out the different methods for sketching your subject described in Demonstration 1.
- 3. Do wear old clothes or an overall when oil painting.
- 4. Do experiment with your brushes to see the different types of marks and effects each brush shape can achieve.
- 5. Do try out the Alla Prima (wet on wet) technique and also the methods which allow each stage to dry.
- 6. Don't forget to turn your sketch upside down to check its accuracy before you paint it.
- 7. Don't forget to try out palette knife painting.
- 8. Don't forget that some of the best subjects are to be found in everyday objects and everyday situations.
- 9. Don't forget to look for, and show, the light, medium and dark tones in your subject and to emphasize the very lightest and the very darkest features in your painting.
- 10. Don't forget to ENJOY your painting.
 - * Remember ... if you have ever said "I wish I could paint" my message to you is IF YOU WANT TO ... YOU CAN